Philip Trager : New York

Philip Trager : New York

FOREWORD BY LOUIS AUCHINCLOSS

WESLEYAN UNIVERSITY PRESS : MIDDLETOWN, CONNECTICUT

For their help with this project, the author wants particularly to thank
Alan Beall Rodgers, Steven Gerber, Robert Geyer, Stephen Schoff,
and Julie Trager. The publishers gratefully acknowledge the support
of the Friends of the Wesleyan University Press Publication Fund.

Library of Congress Cataloging in Publication Data
Trager, Philip, 1935-
 New York.

 1. Manhattan (Borough)—Description—Views.
2. New York (City)—Description—1951- —Views.
I. Auchincloss, Louis. II. Title.
F128.37.T7 779'.997471 80-15741
ISBN 0-8195-5051-5
ISBN 0-8195-8042-2 (spec. ed.)

Distributed by Columbia University Press
136 South Broadway, Irvington, NY 10533

Manufactured in the United States of America
First edition

V.S.W., Gift of Publisher, 24 September 84

For Ina

Foreword

Philip Trager has confined his volume to Manhattan. I am convinced that only thus can a photographer have any chance of catching the peculiar, the unique flavor of what is conveyed by the name "New York." Brooklyn may have its architectural glories; Bronx its great zoo and gardens; Queens its spreading vistas, and Staten Island its fields and beaches, but it is only in Manhattan, where masonry is so tightly packed that it seems to explode into the sky, that the true soul of our City resides. It is possible to imagine the other boroughs as attached to other metropolises, but Manhattan could be only what it is and where it is.

Many, perhaps most, photographers have been fascinated by the teeming humanity and the roaring traffic of New York. Others have reveled in the intimate, evocative detail: the solitary, overflowing ash can, the organ grinder, the drunk asleep on the park bench. But Trager is after a different goal. His city has no districts: business, theatre, residential, or political; he ignores luxury and poverty alike. People appear in his pictures only when he has been unable to dispose of them; even the automobile is largely eliminated. Trager seeks height and angles, density and mass. His Manhattan is what is imprinted on the individual's eyeball as he walks to work, or gazes out of high windows, on a crisp, clear, bright, early winter morn. He may be looking up or looking down, but he is always alone and always aware of the enveloping sky.

Perhaps one has to have lived in Manhattan to know how remarkably Trager has caught the effect of huge objects on our daily lives. We all have to

make our own terms with the skinny island, and in doing so we have no help from our fellows. It is a solitary business. As a devout individual makes his peace with God, so does the New Yorker make his peace with skyscrapers and gridiron streets and avenues. Trager confronts us with the strange spirituality of even the grossly material, with the unearthiness of things most earthy.

It is at times depressing, at times even appalling; it is always moving; it is occasionally thrilling. The great glass monolithic slabs, the shabby, elegant brownstones, the huge, rough statues gazing mournfully at pavements or blank walls, the seeming infinity of windows, the rare, bare leafless trees, the signposts which want to shout and yet are strangely muted, and, above all, the curious homogeneity of the disparate elements, the very "New Yorkness" of it all, impossible to describe, impossible to miss—these are some of the things that evoke that blend of muffled elation and mild sadness that is of the essence of our urban experience.

There is no way that one can take Trager's New York apart; each piece contains too much of the whole. The Stock Exchange might be a church or temple; St. John's cathedral, a fortress; old rotting warehouses seem aristocratic, and new office buildings—square blocks with square windows—the dullest of burghers. Perhaps one comes as close to an essence as one can in the lonely, art-deco gargoyle of the Chrysler Building sticking its defiant beak into the enshrouding eternity of grey clouds, a desperate little bid of crude individuality against the enveloping void. **LOUIS AUCHINCLOSS**

Philip Trager : New York

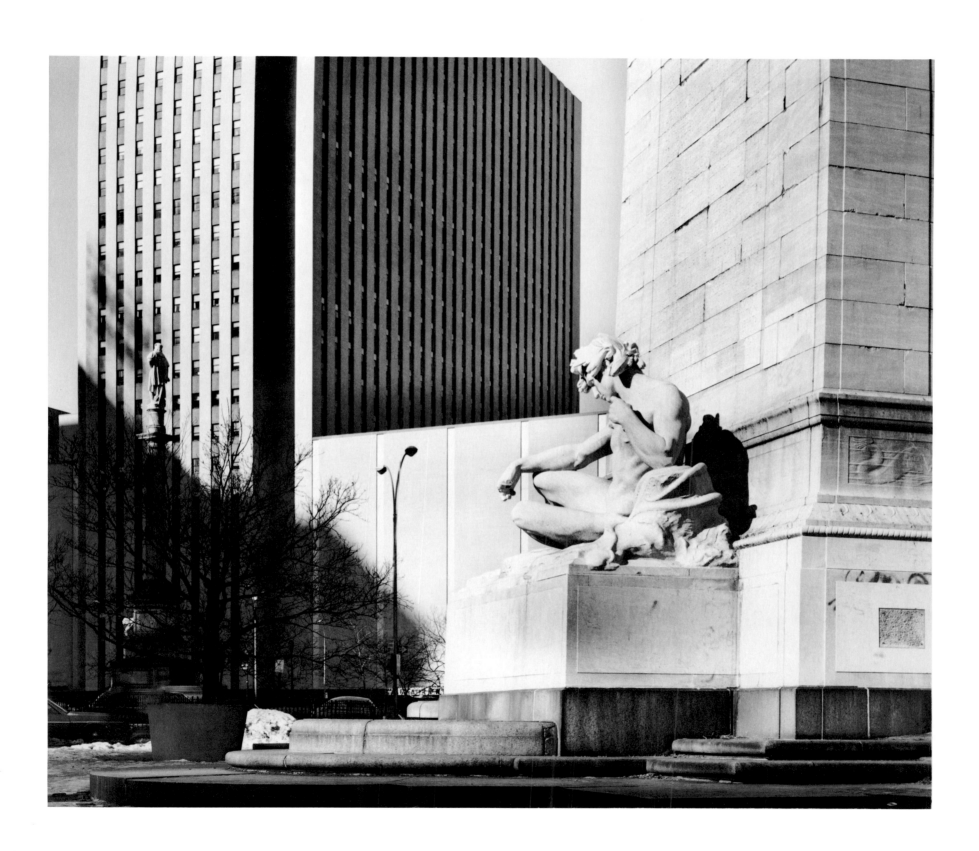

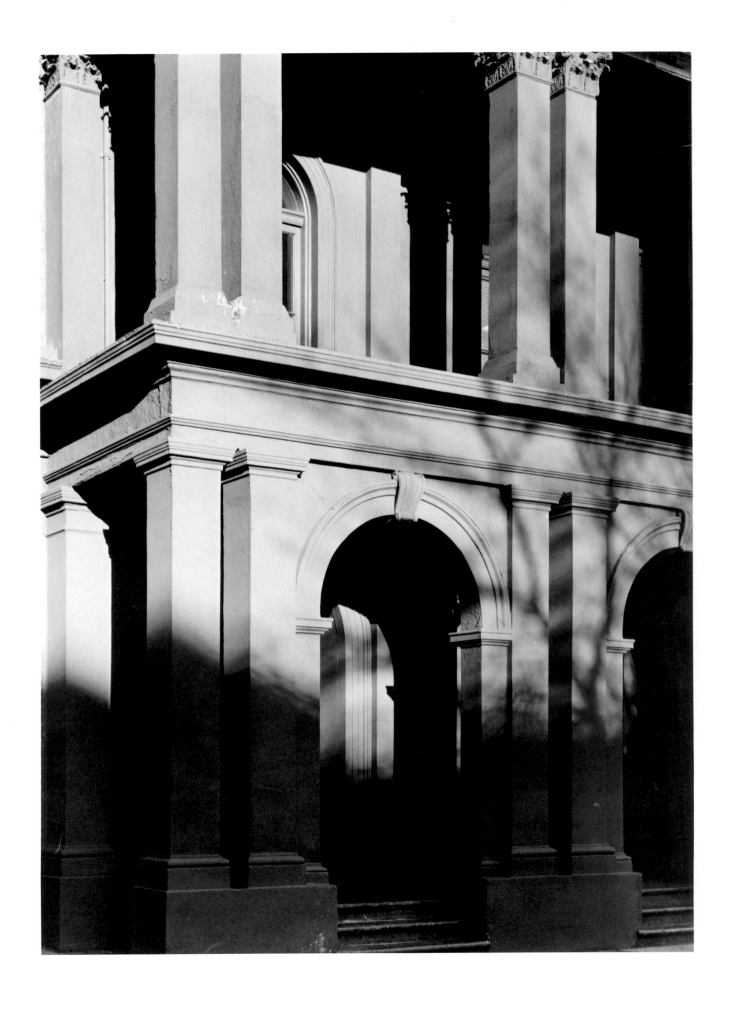

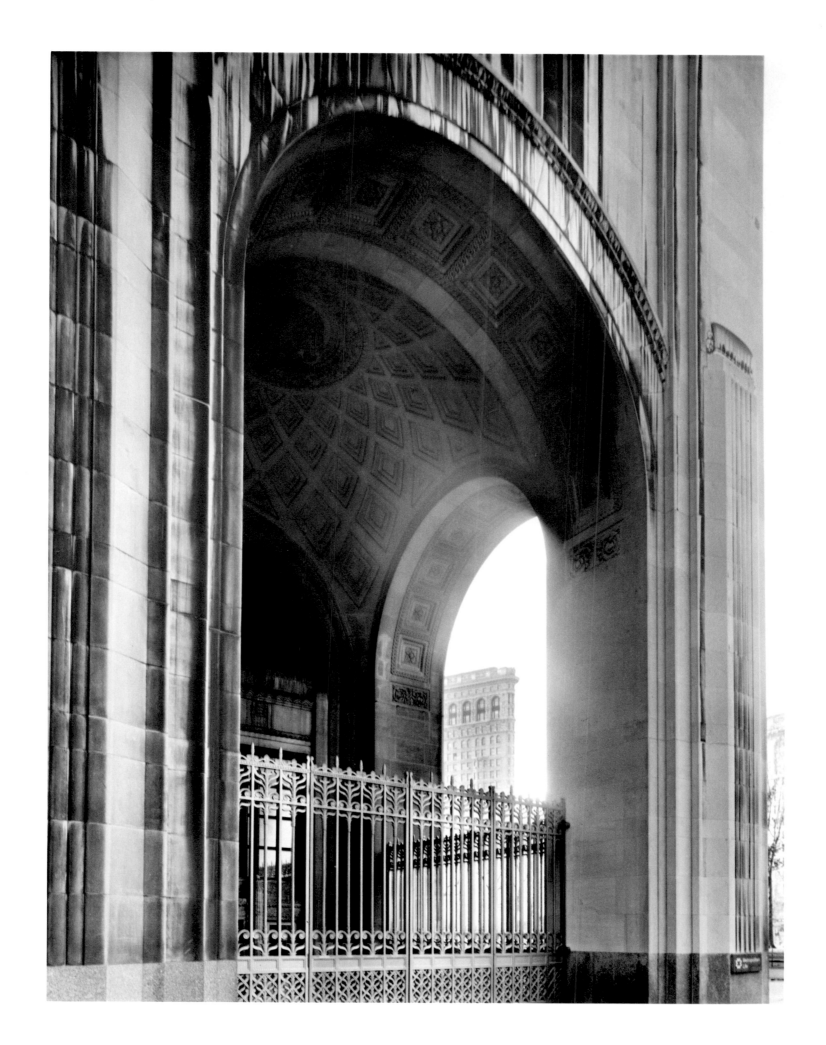

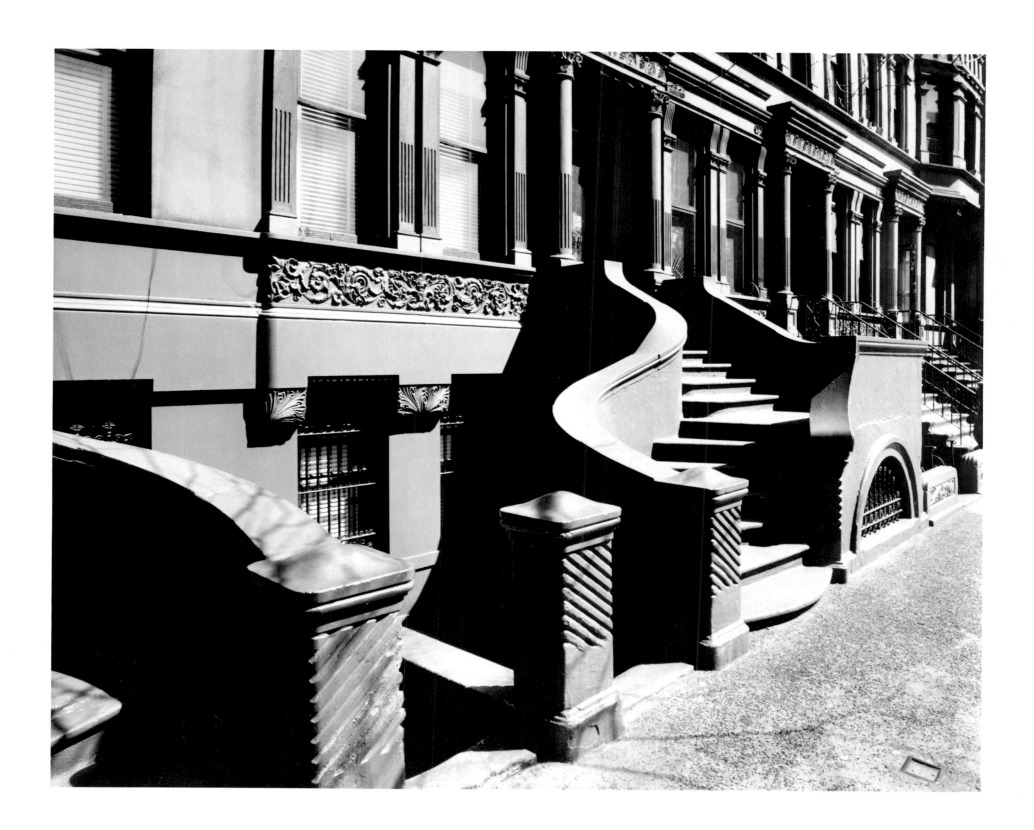

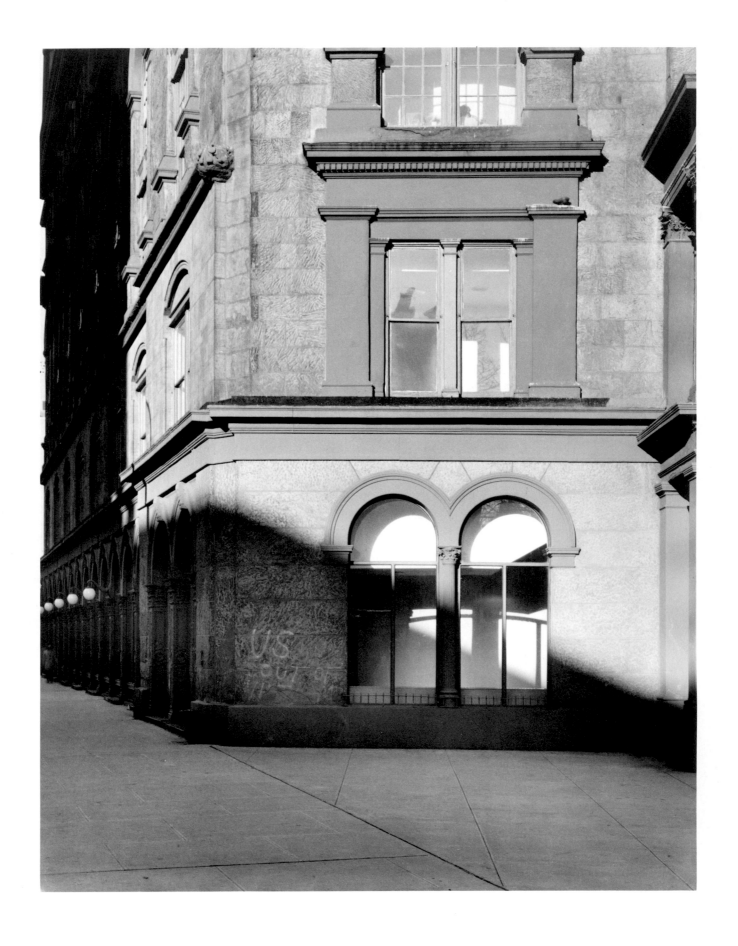

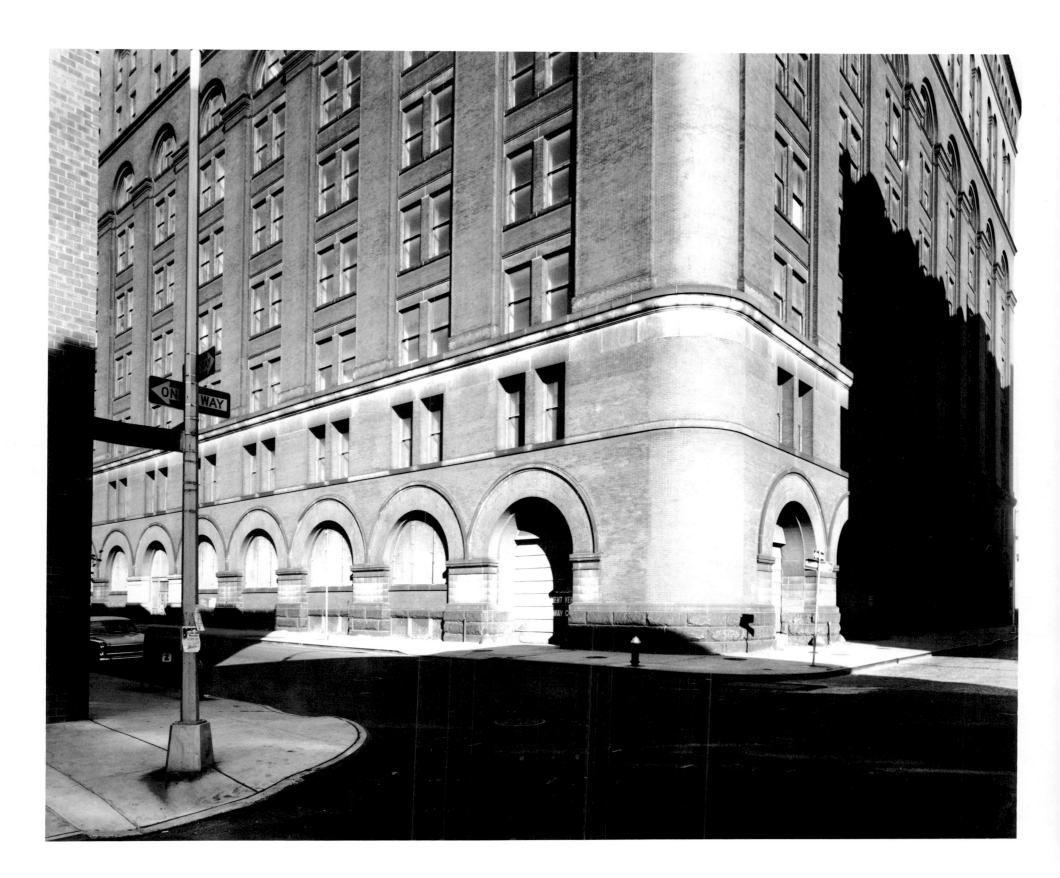

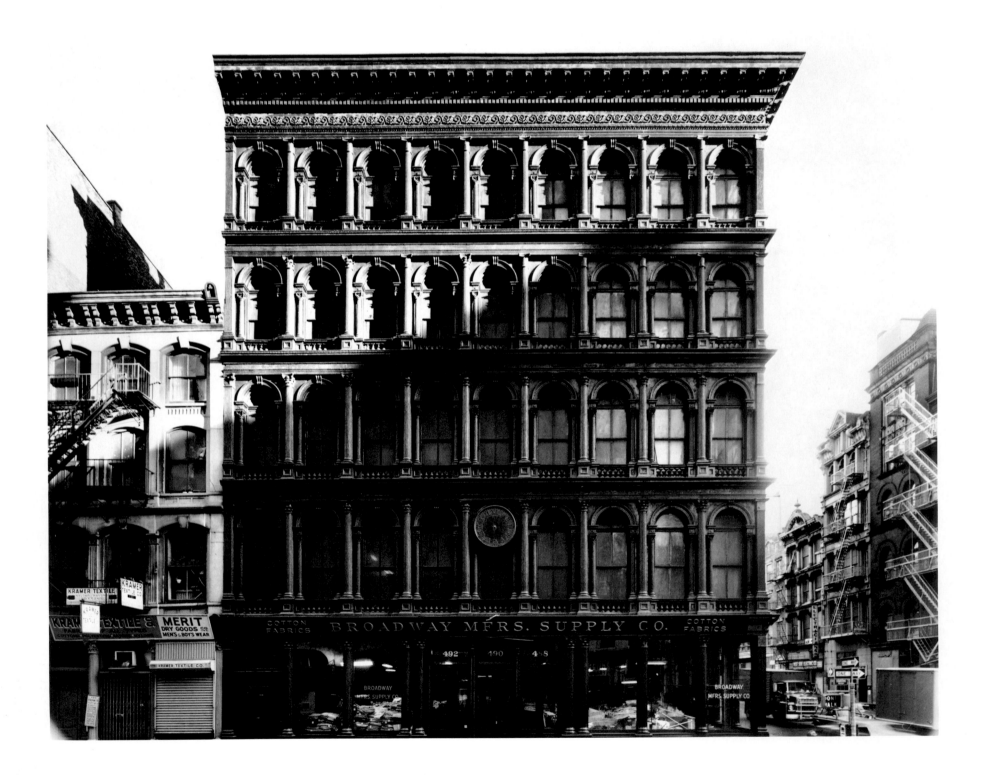

18

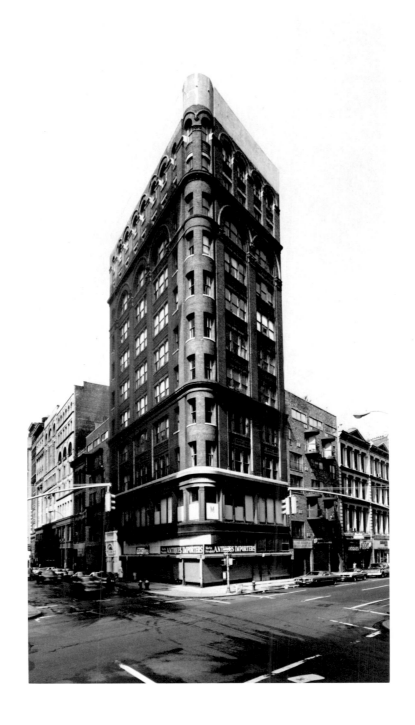

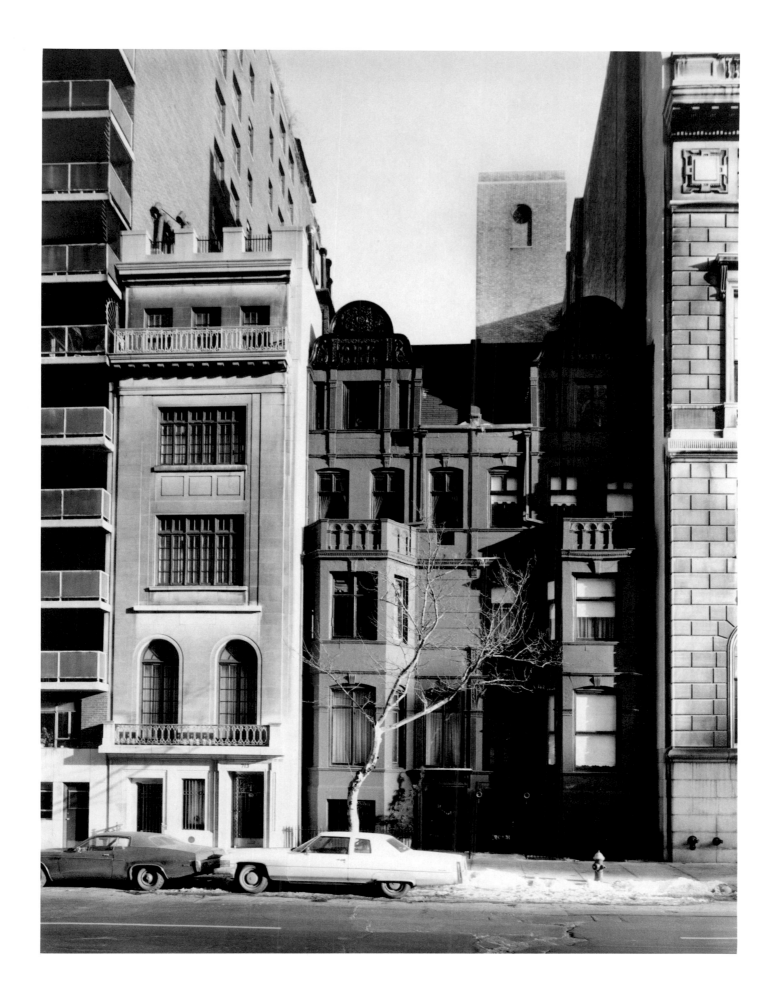

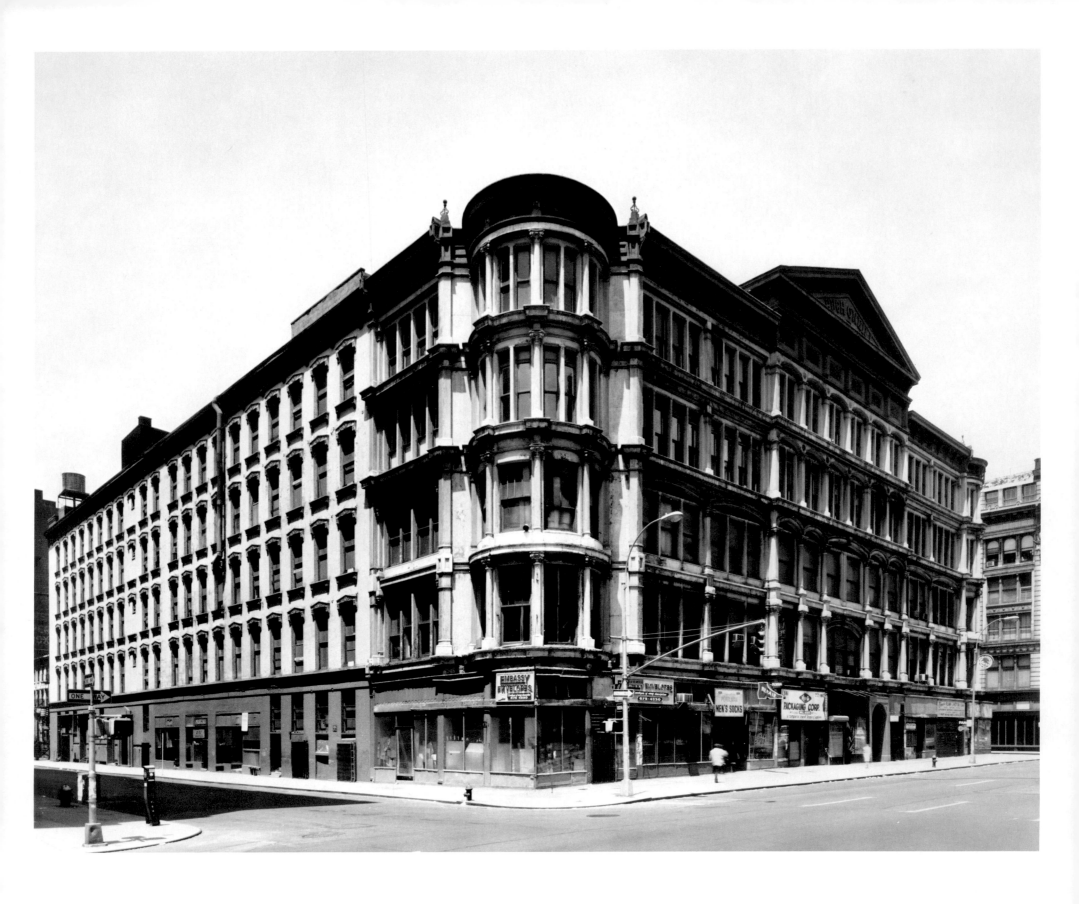

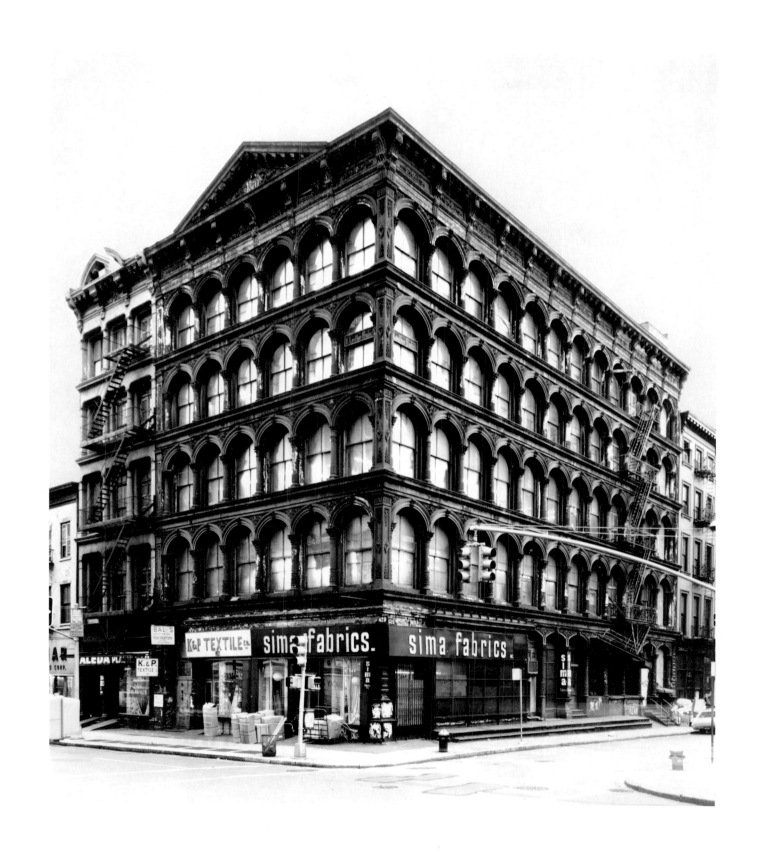

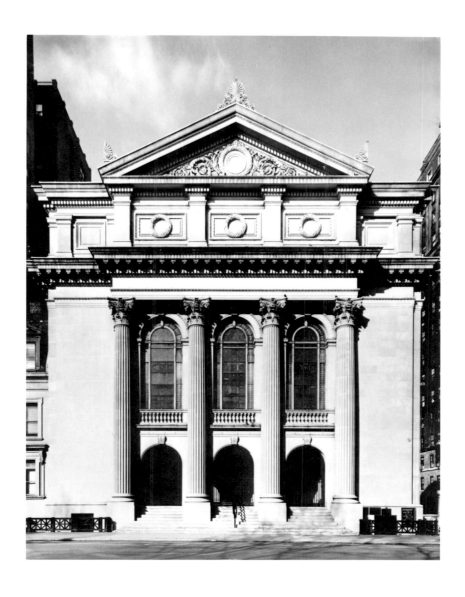

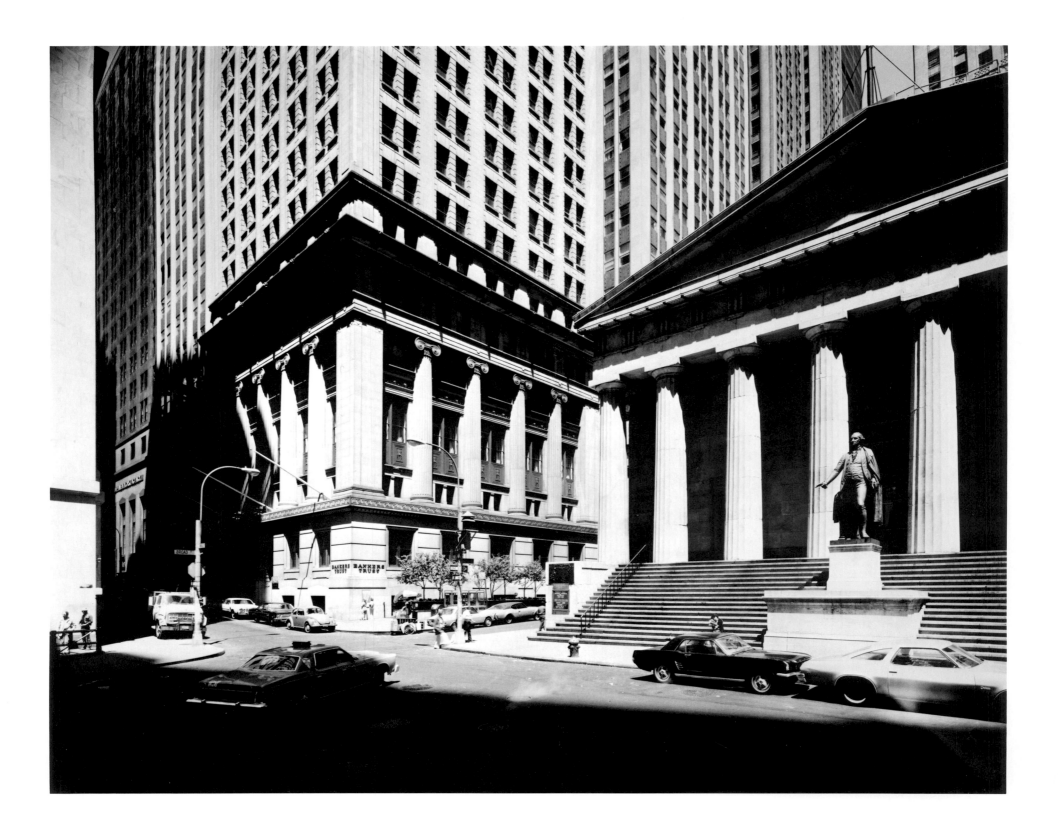

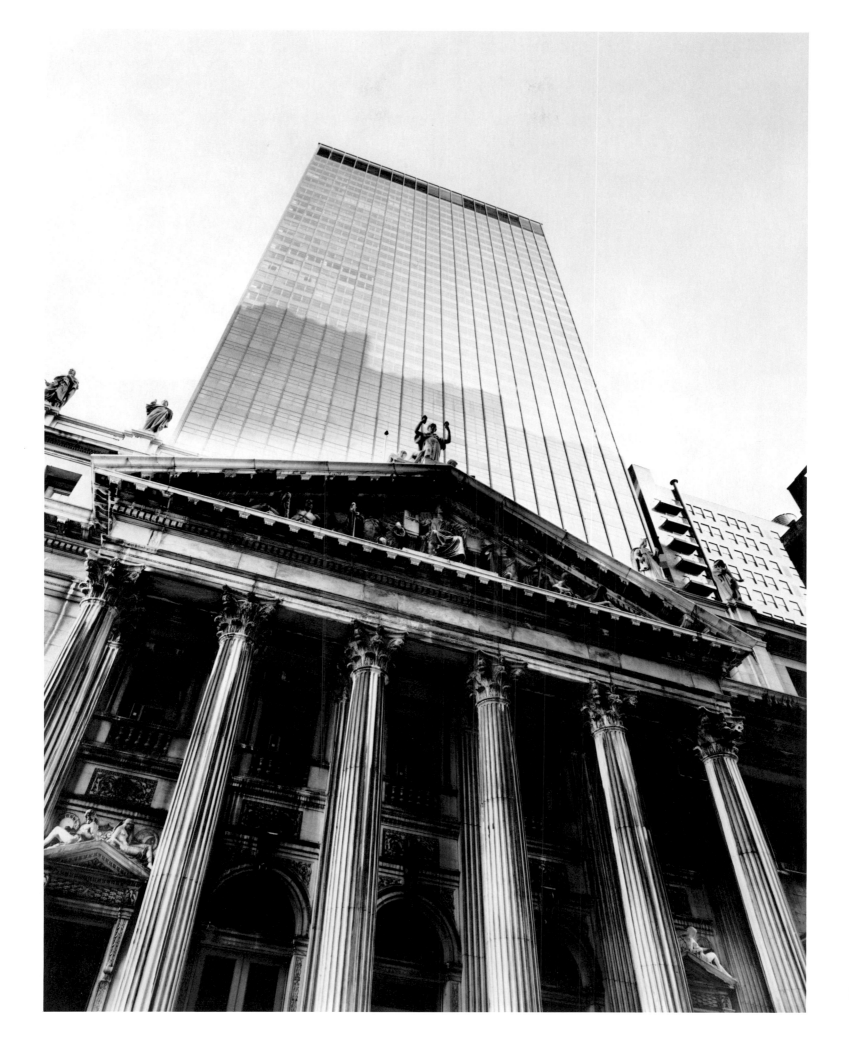

27

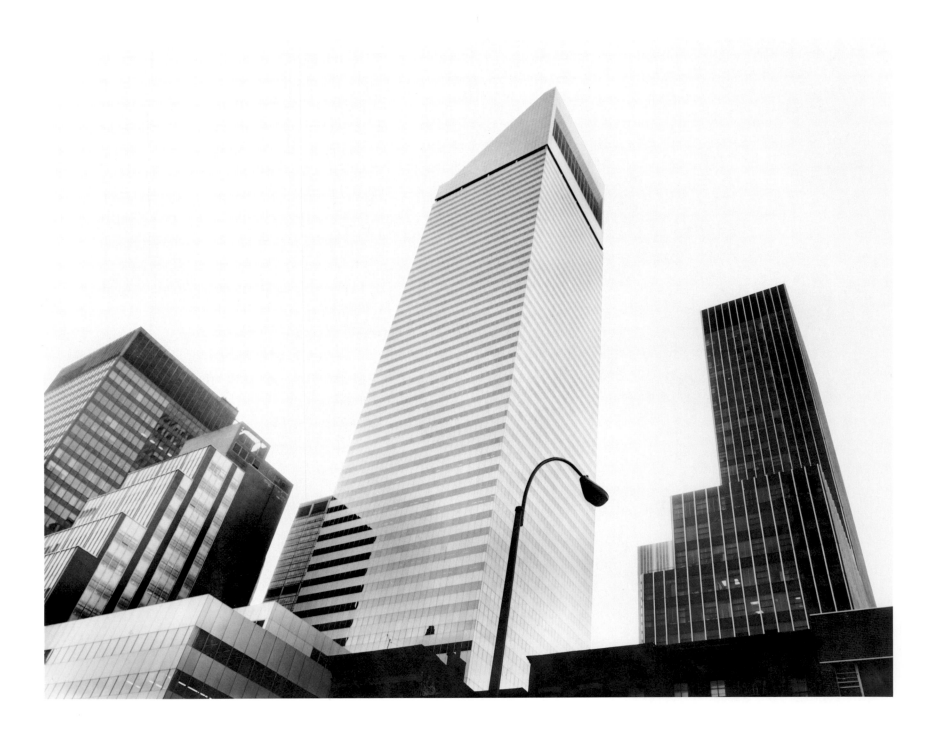

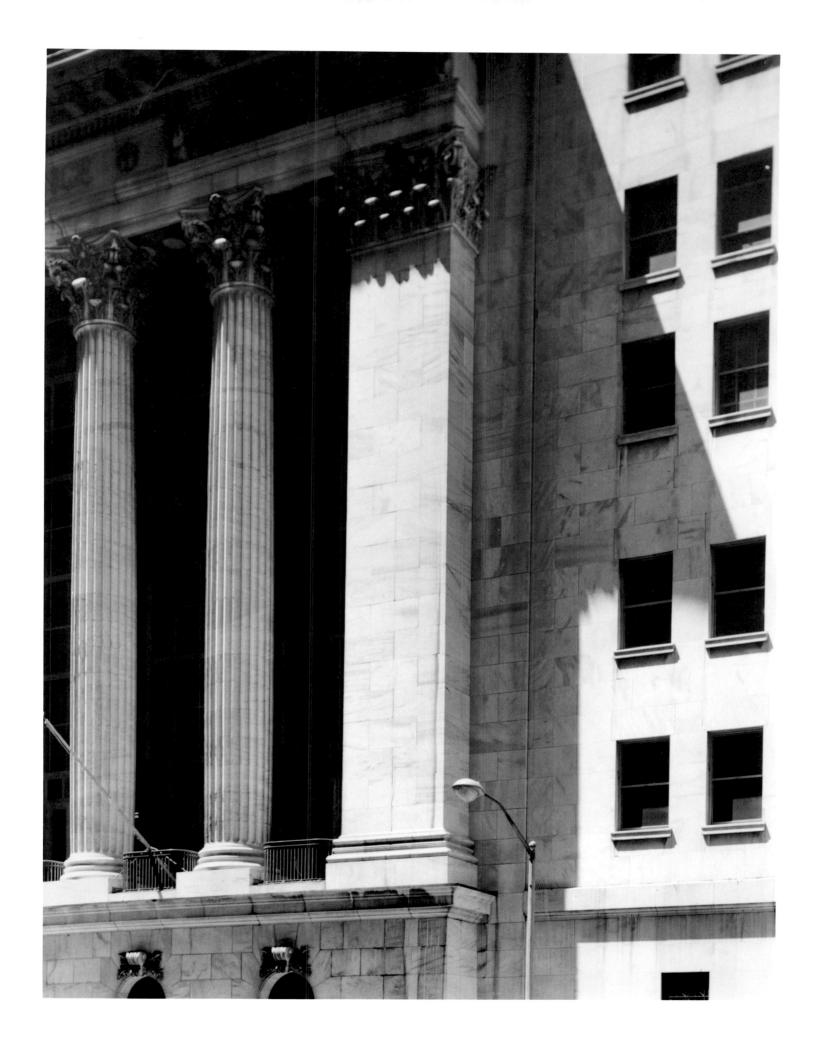

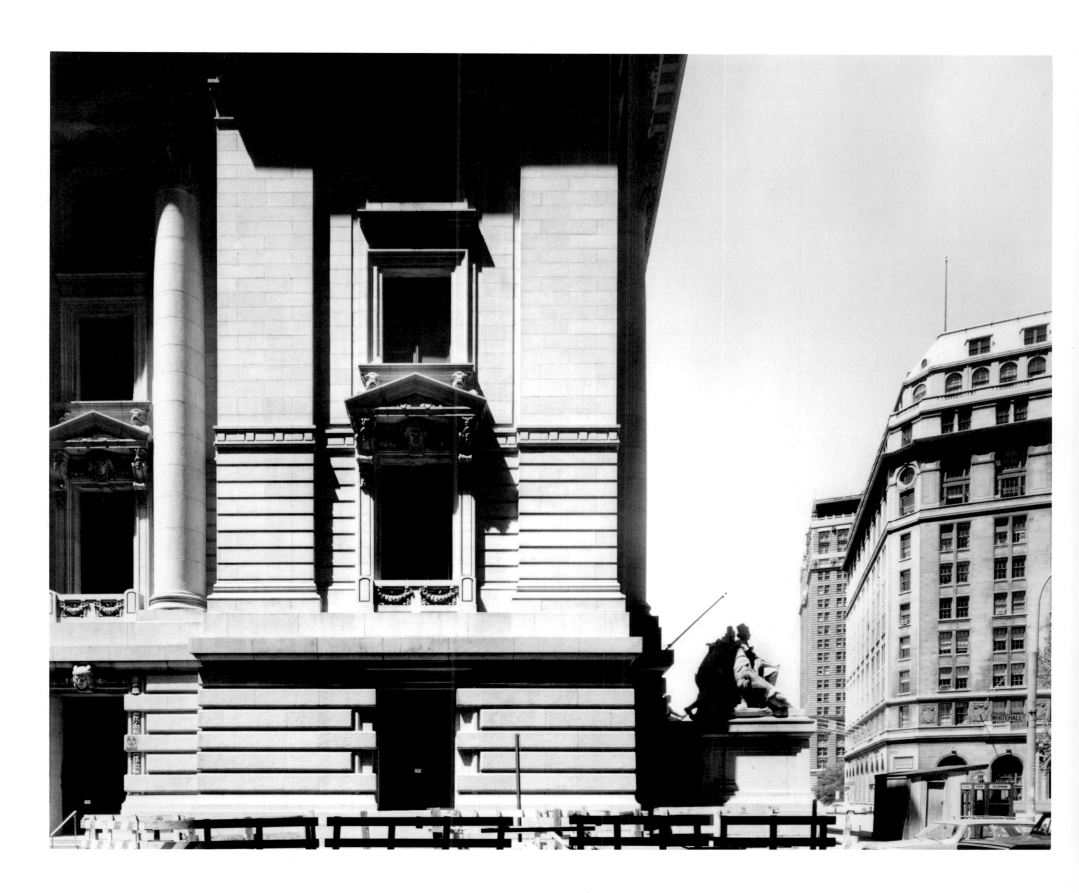

31

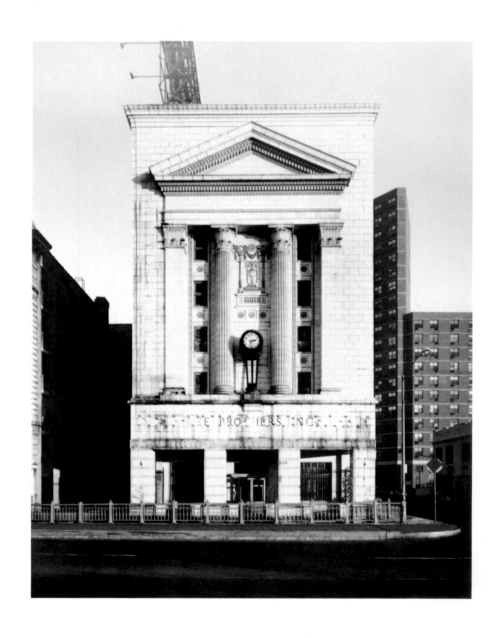

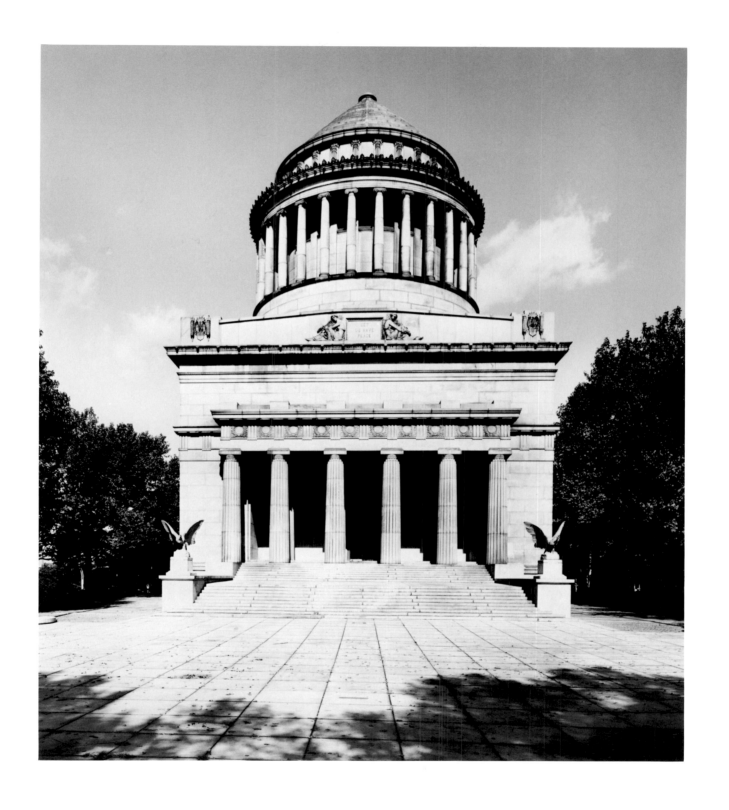

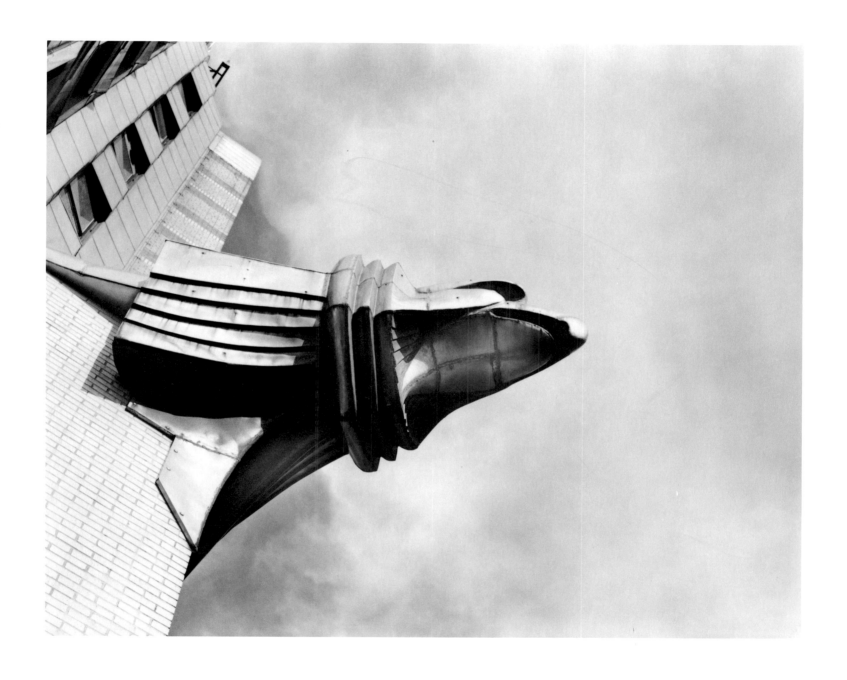

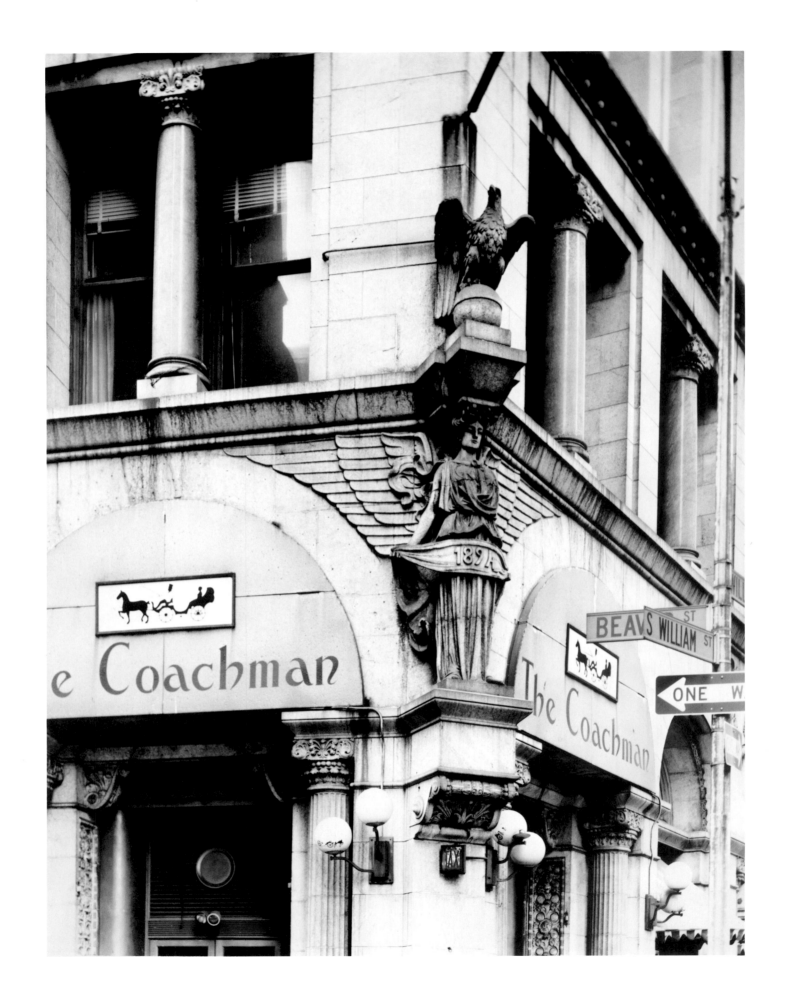

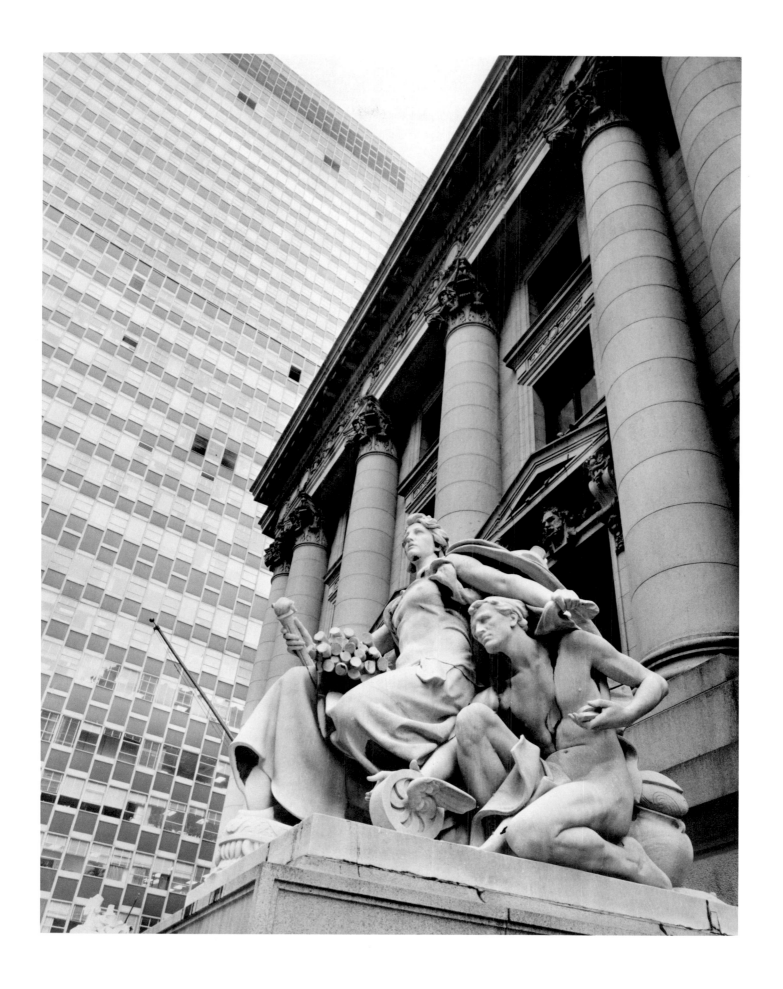

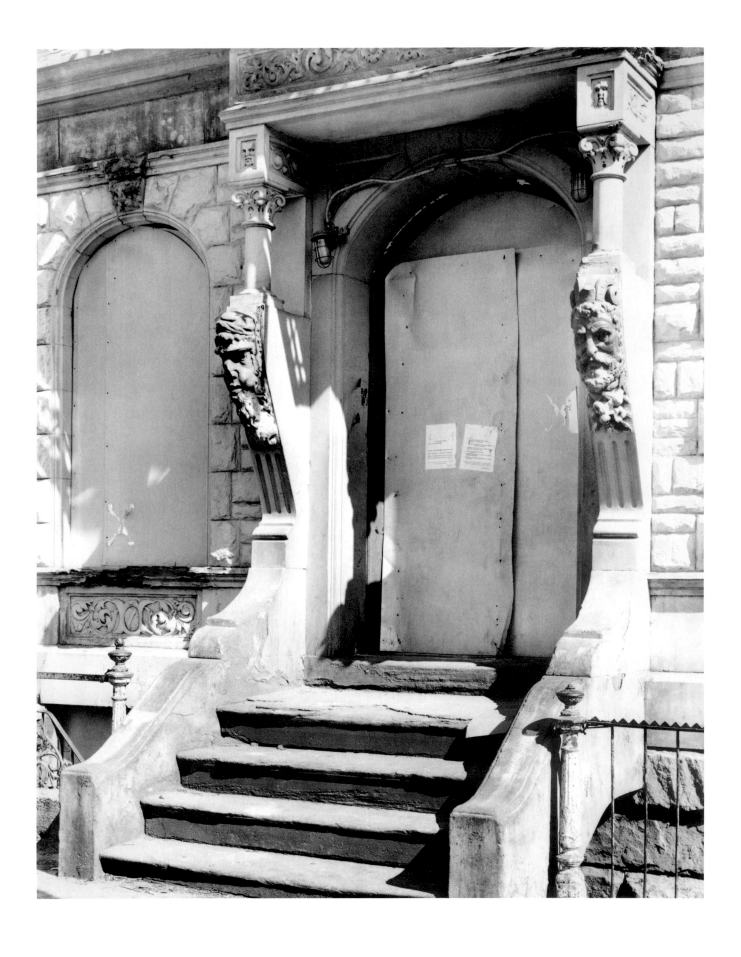

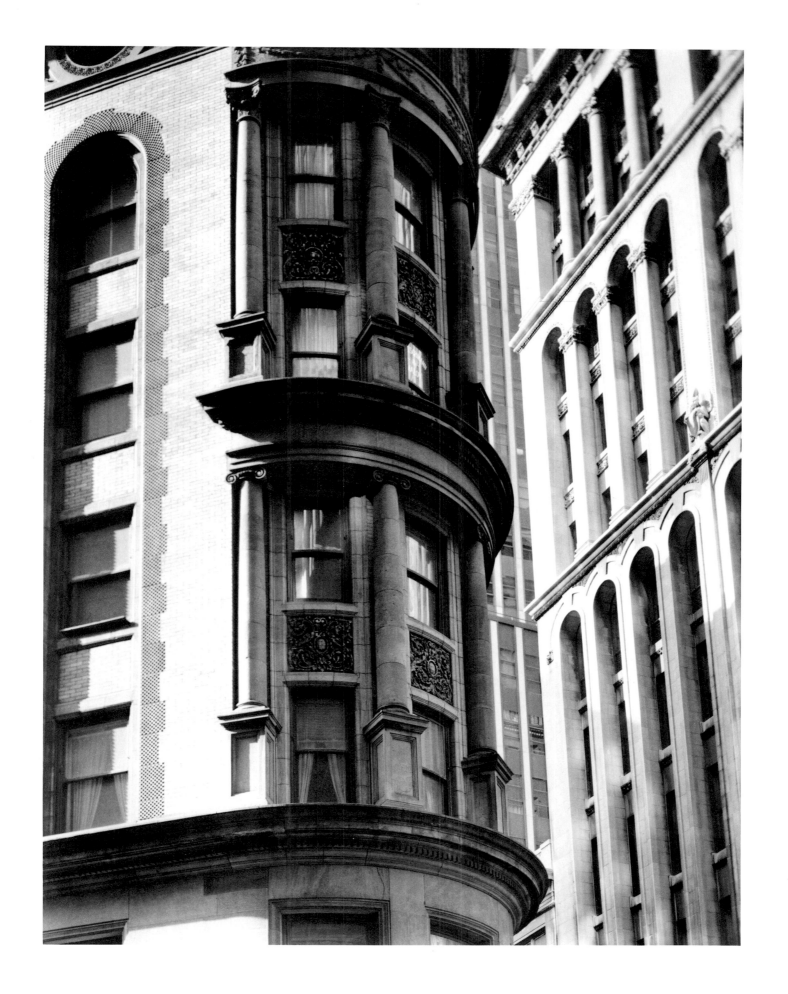

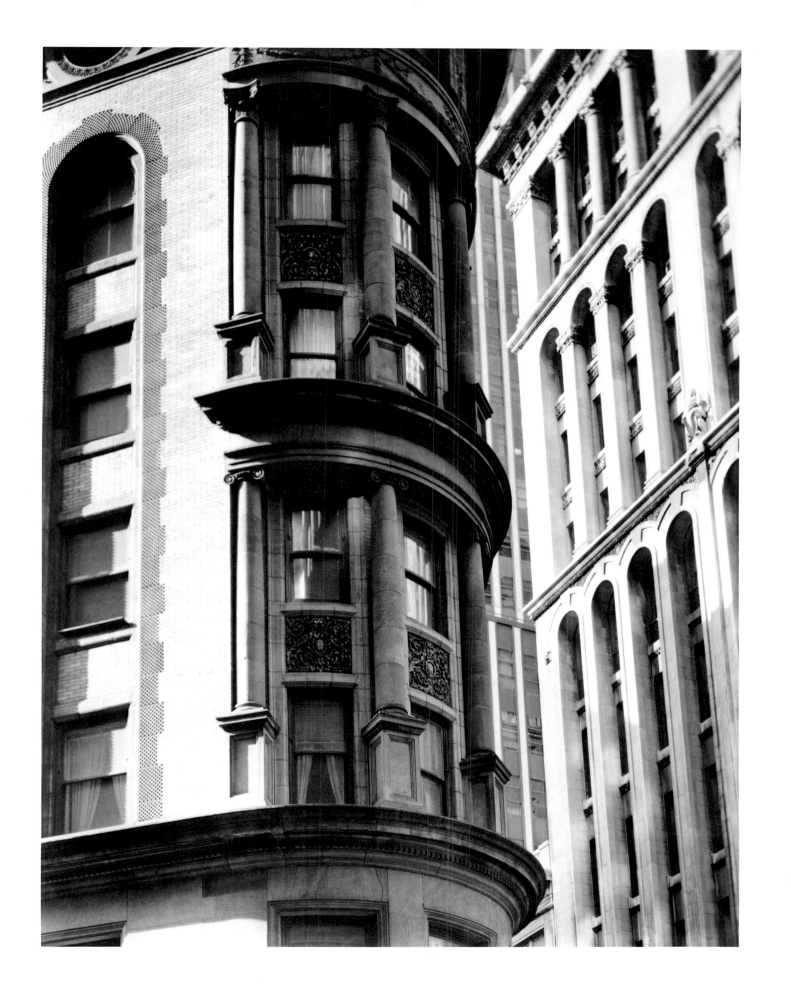

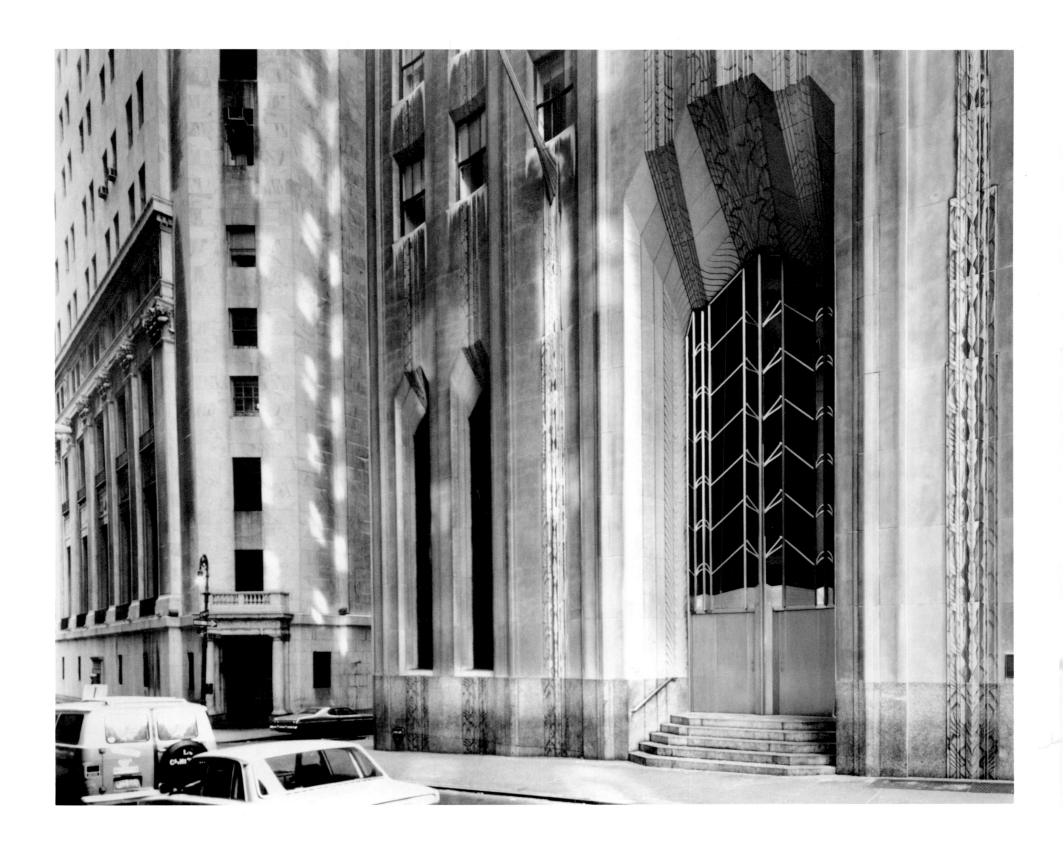

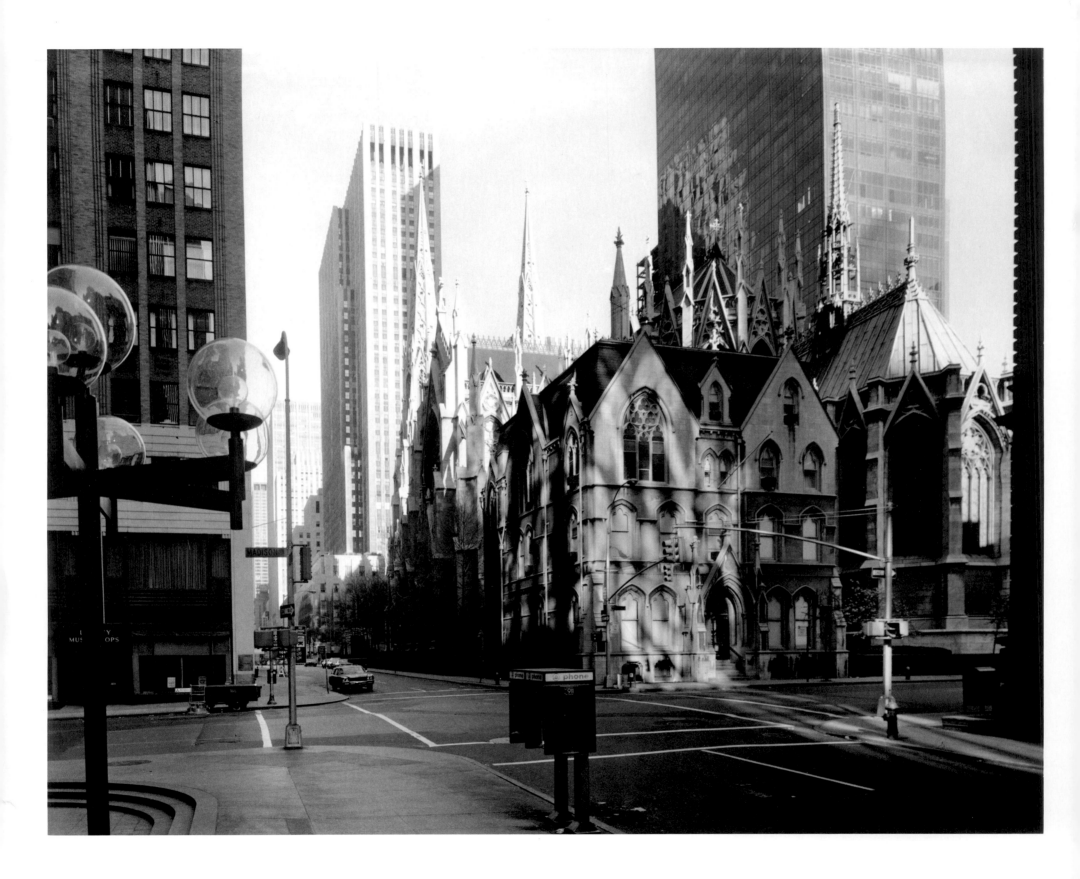

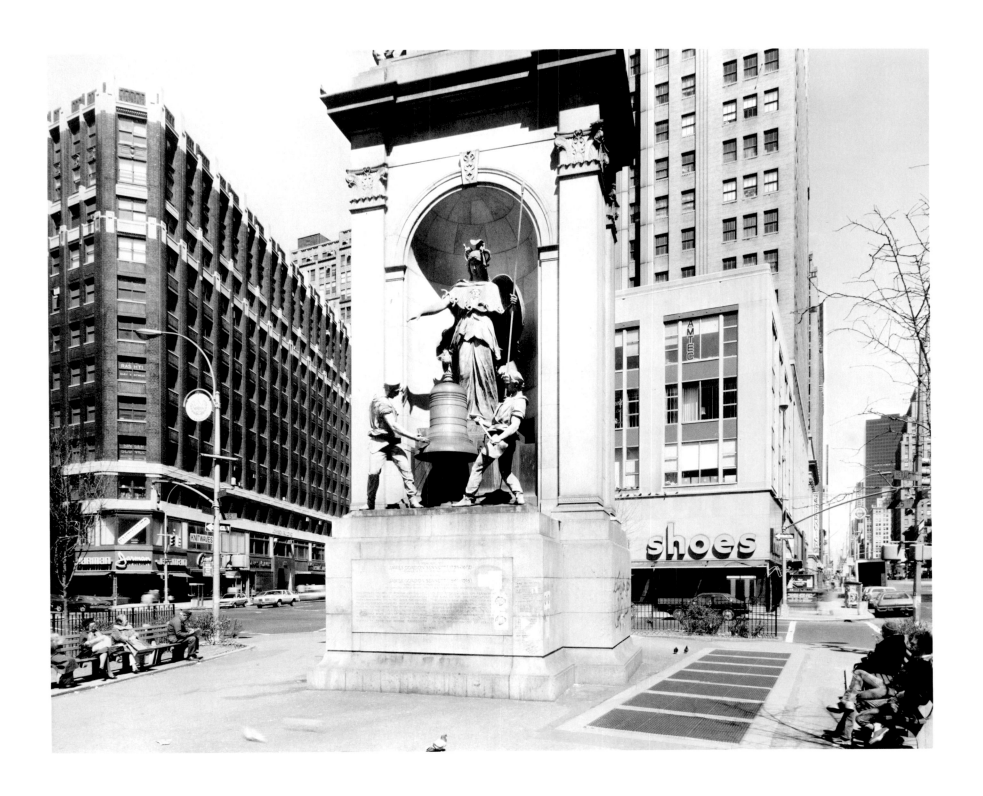

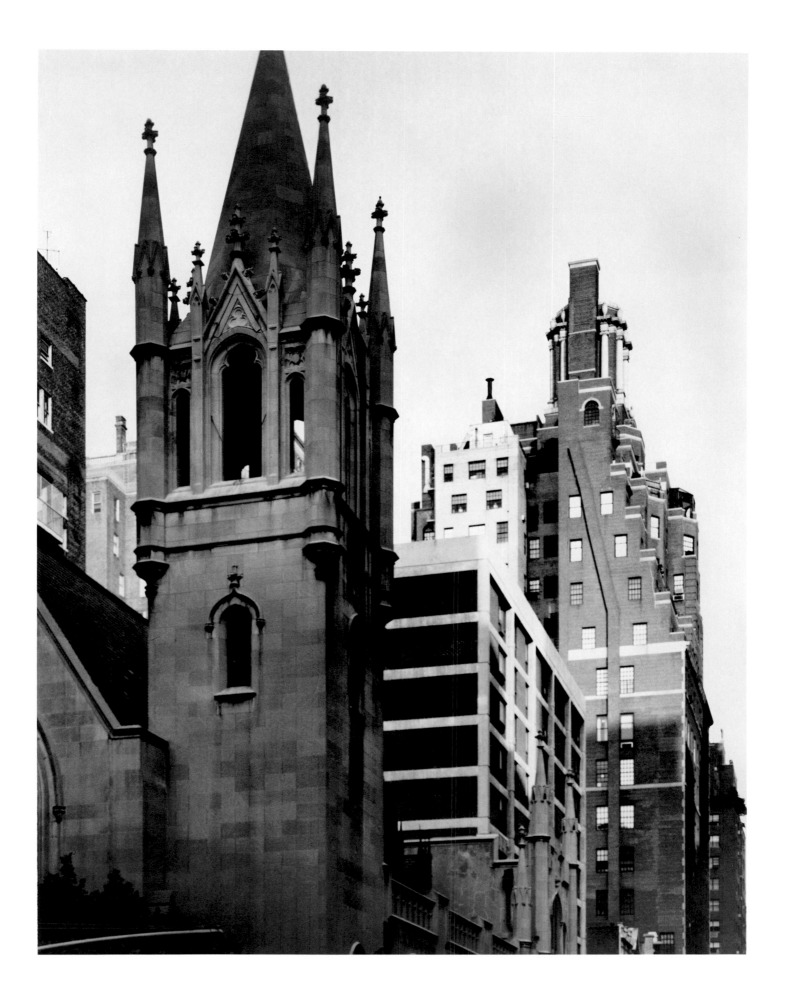

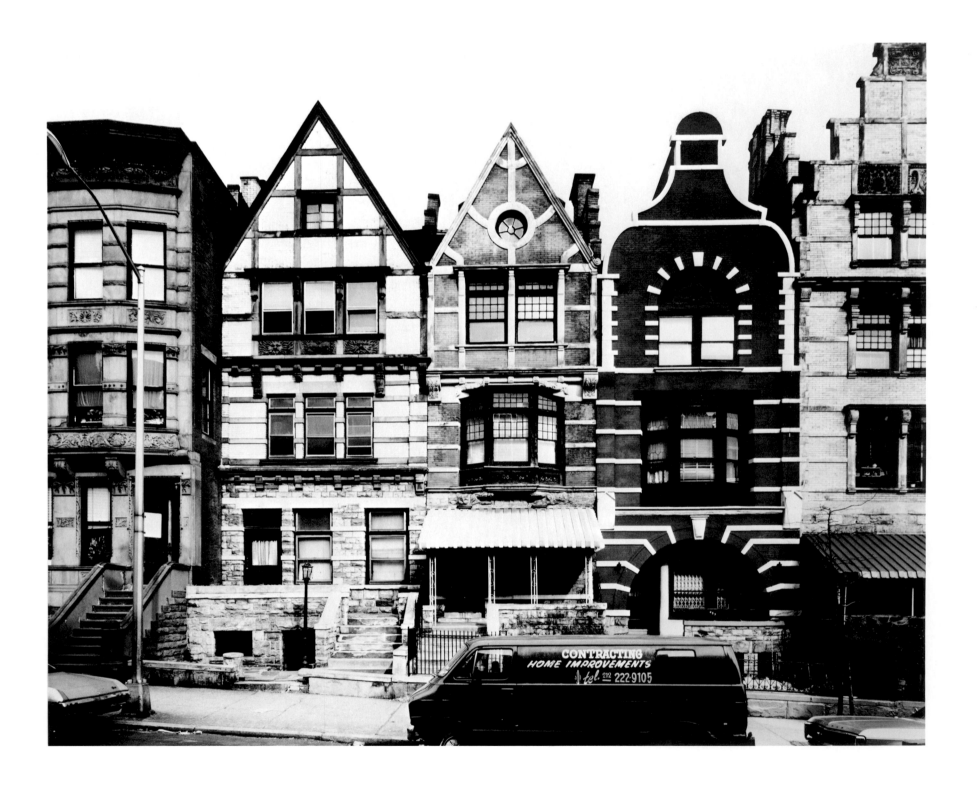

46

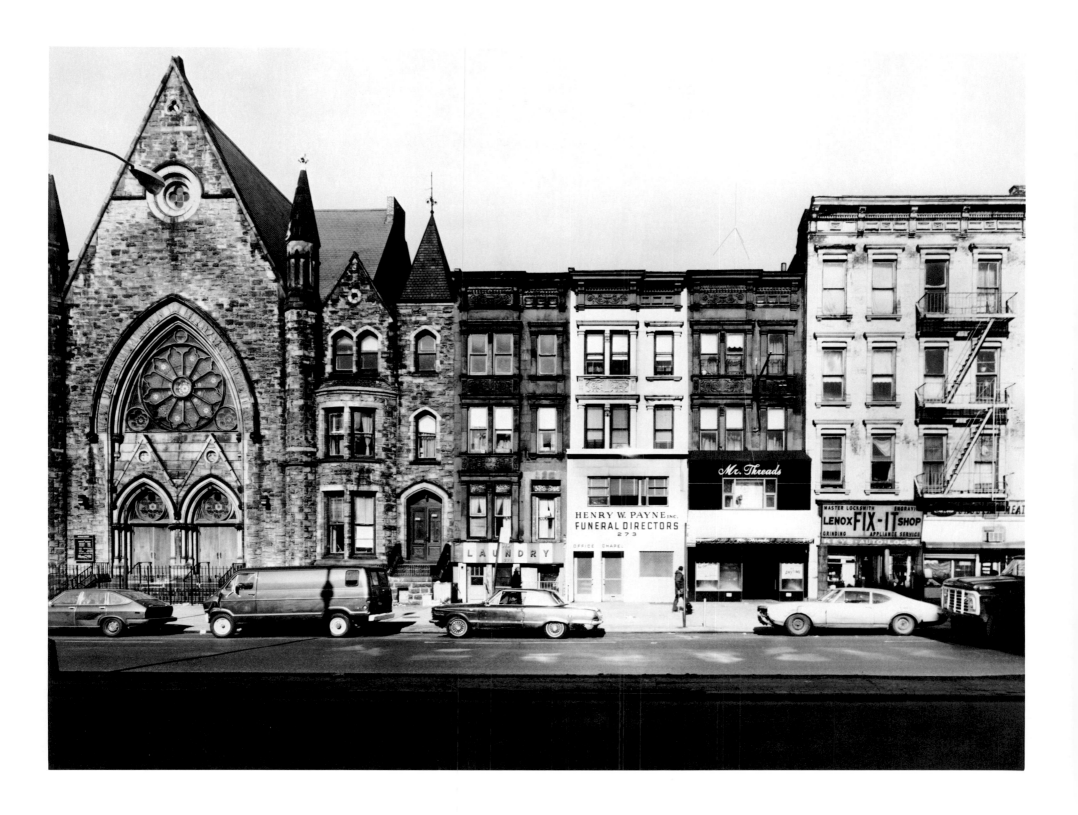

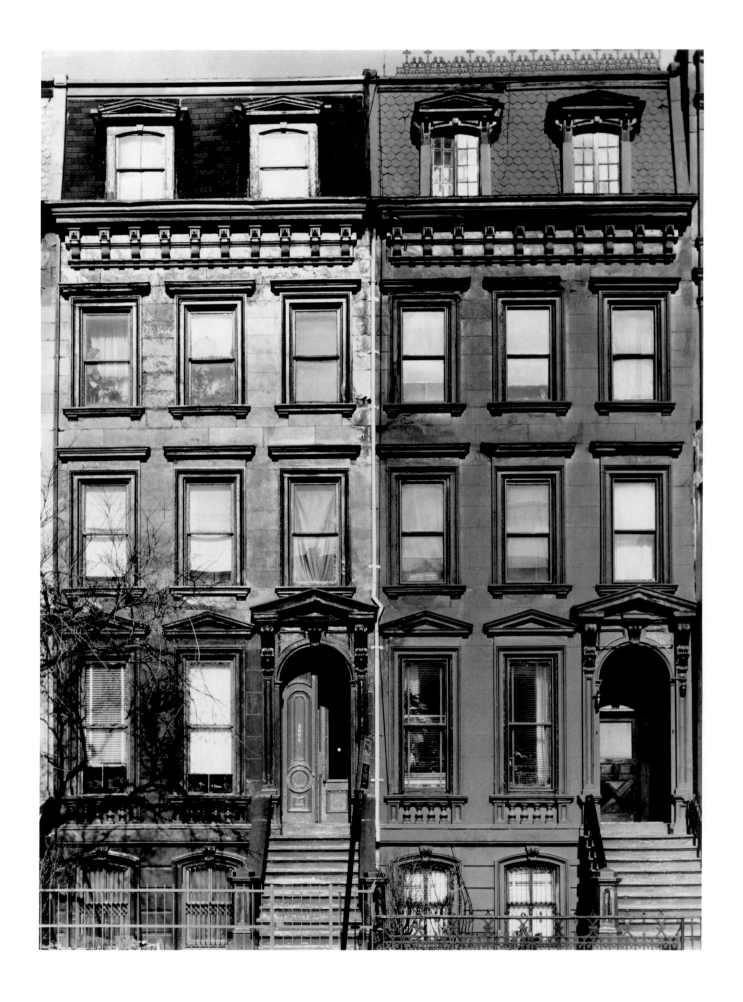

48

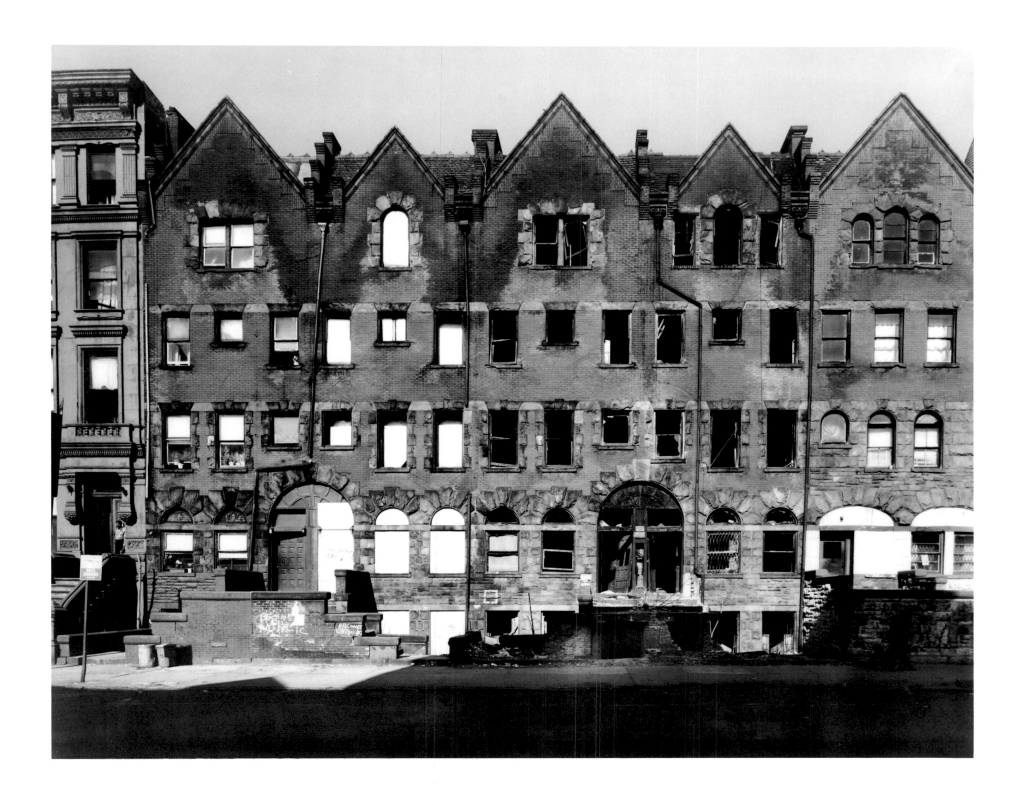

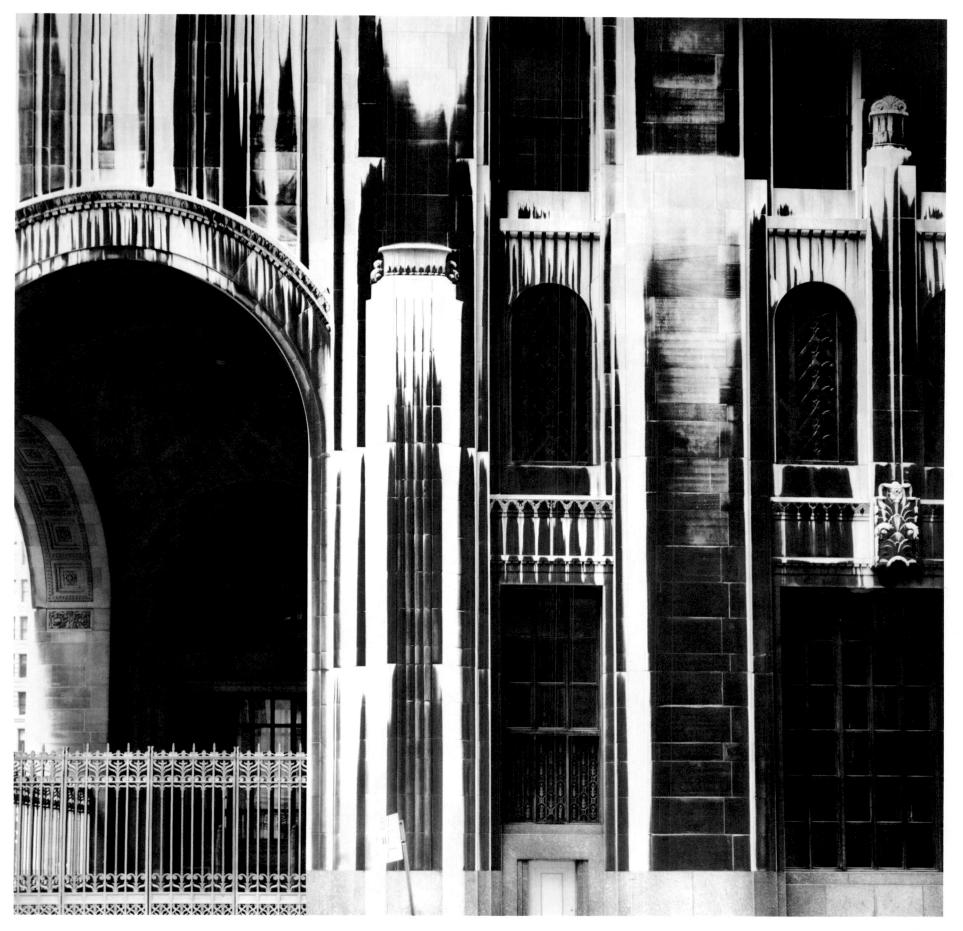

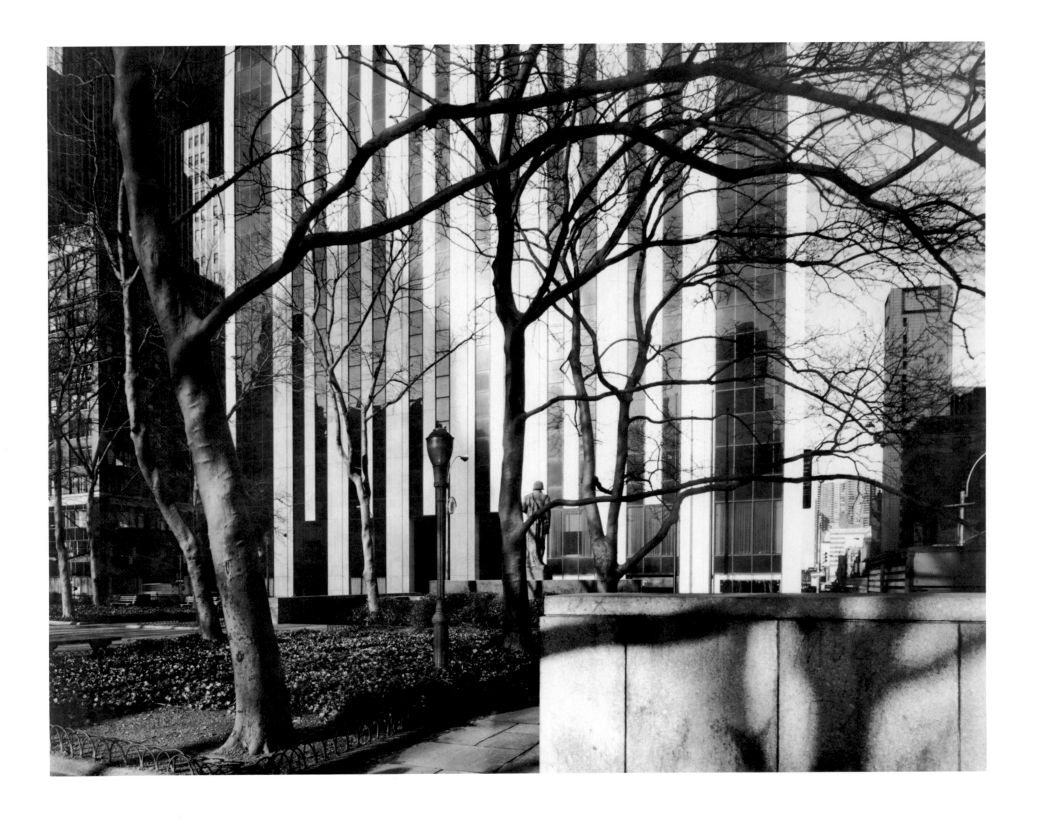

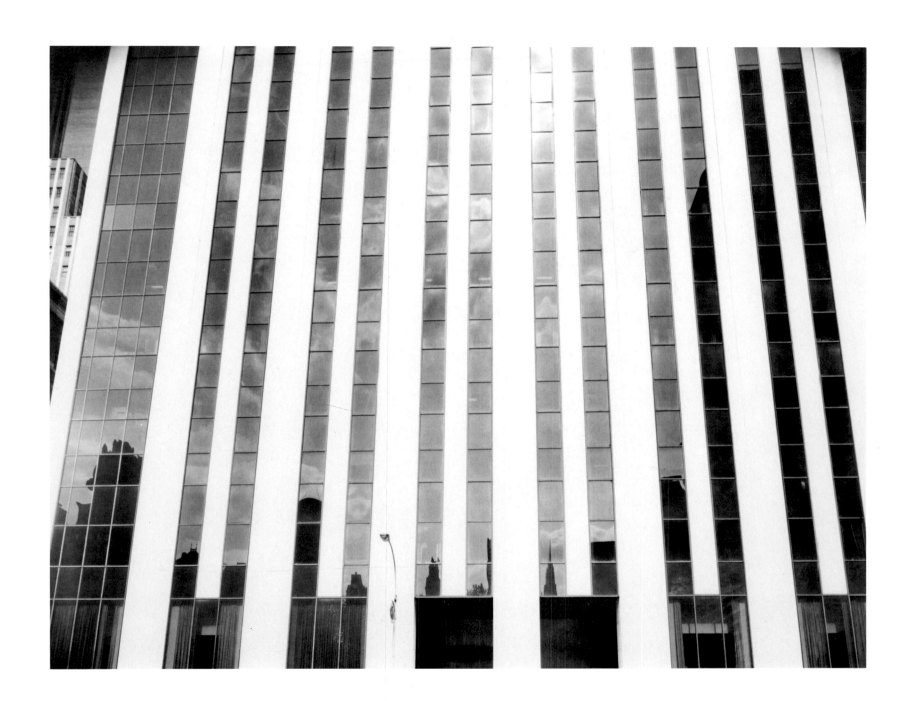

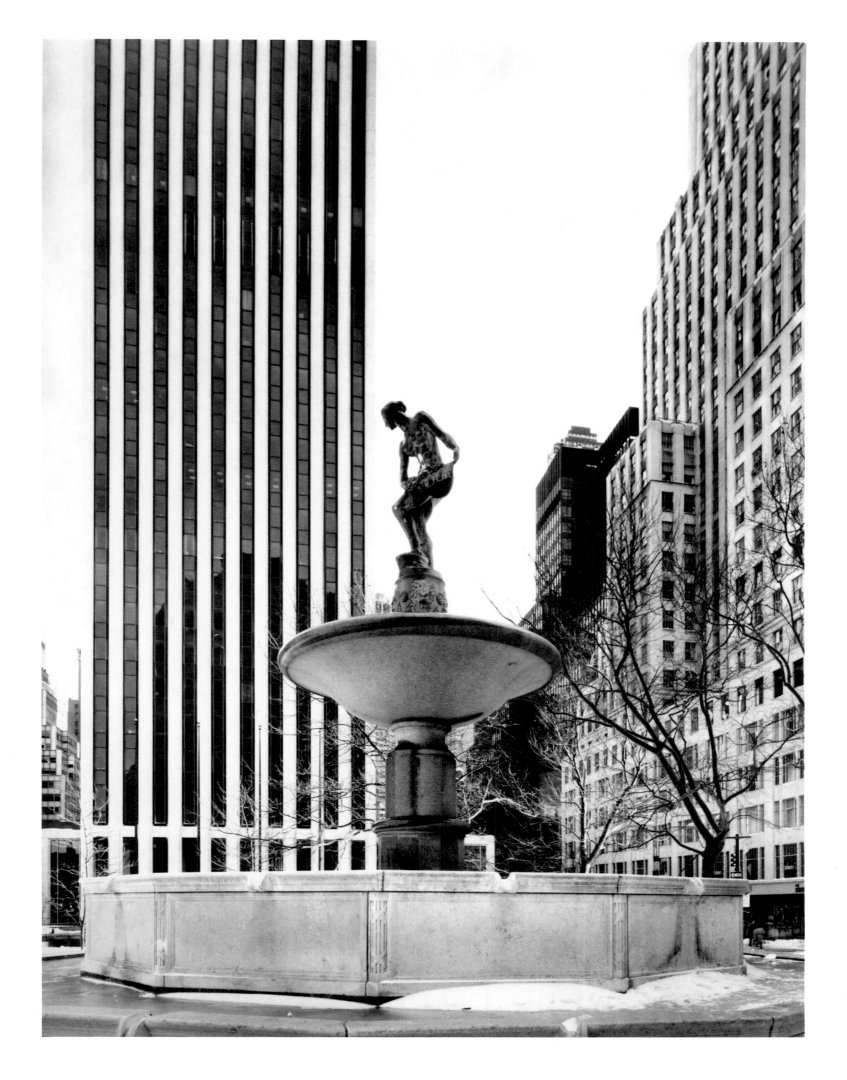

55

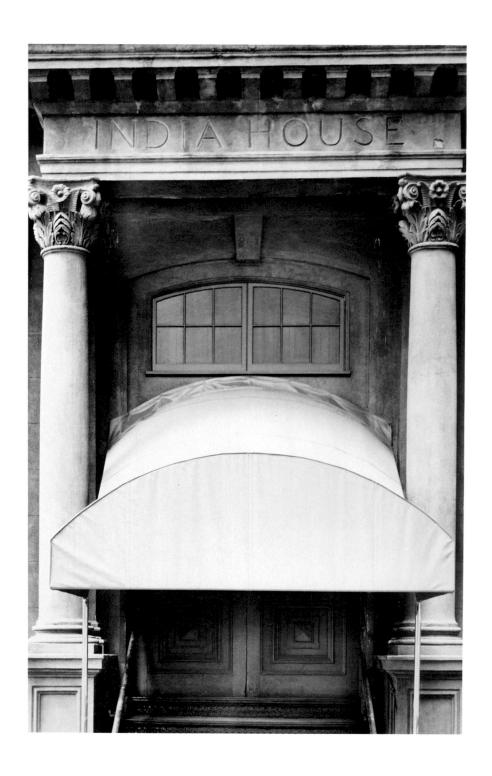

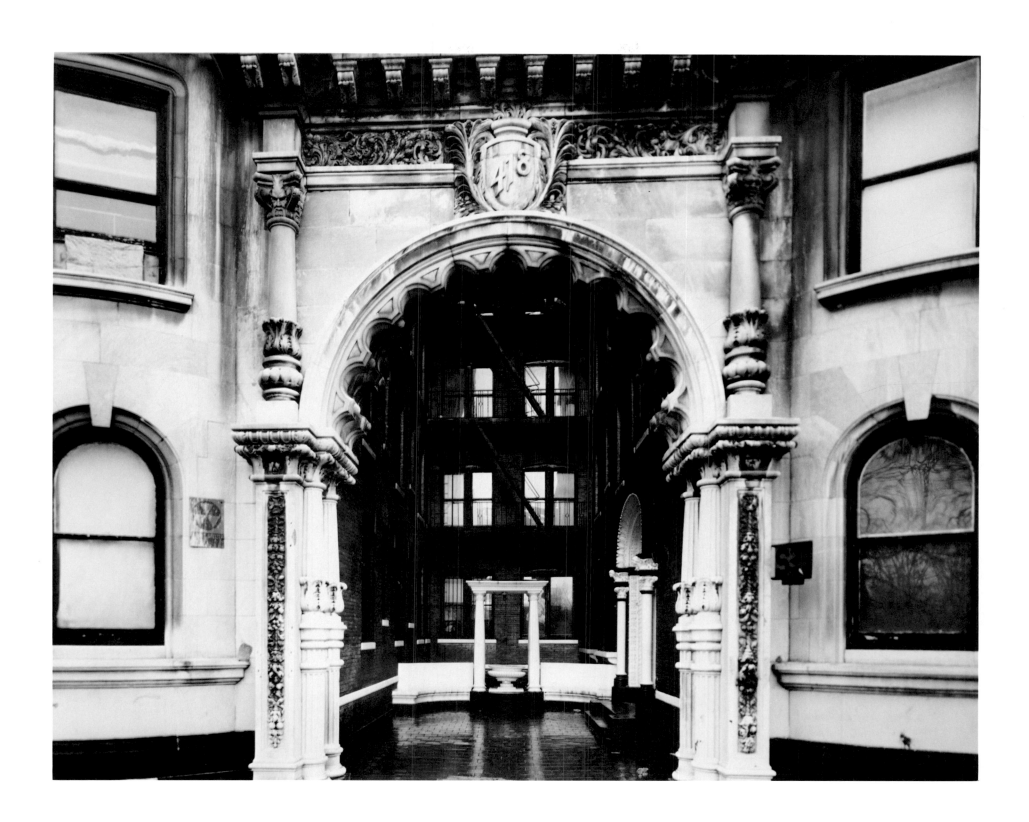

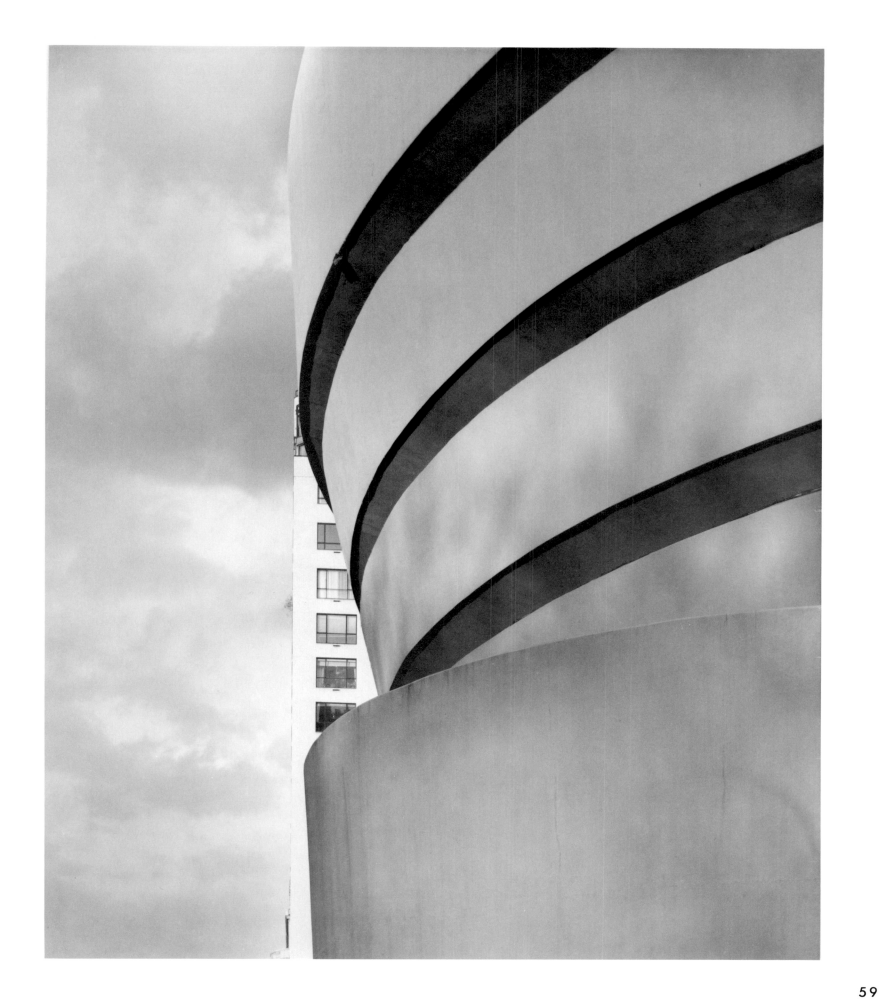

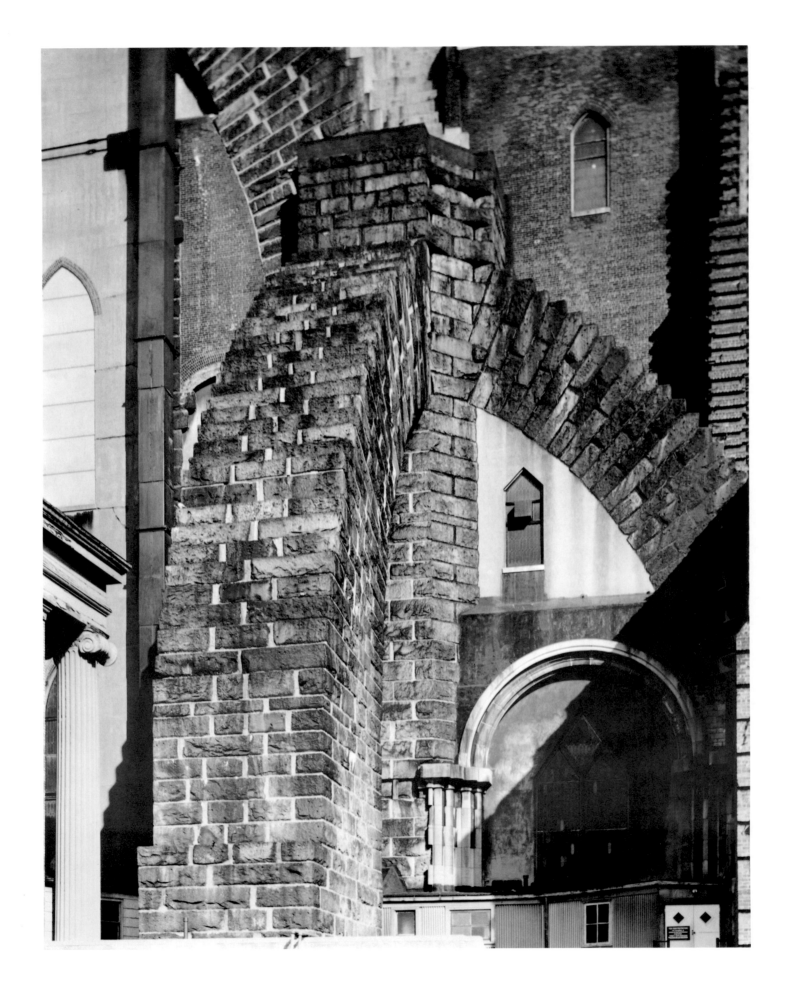

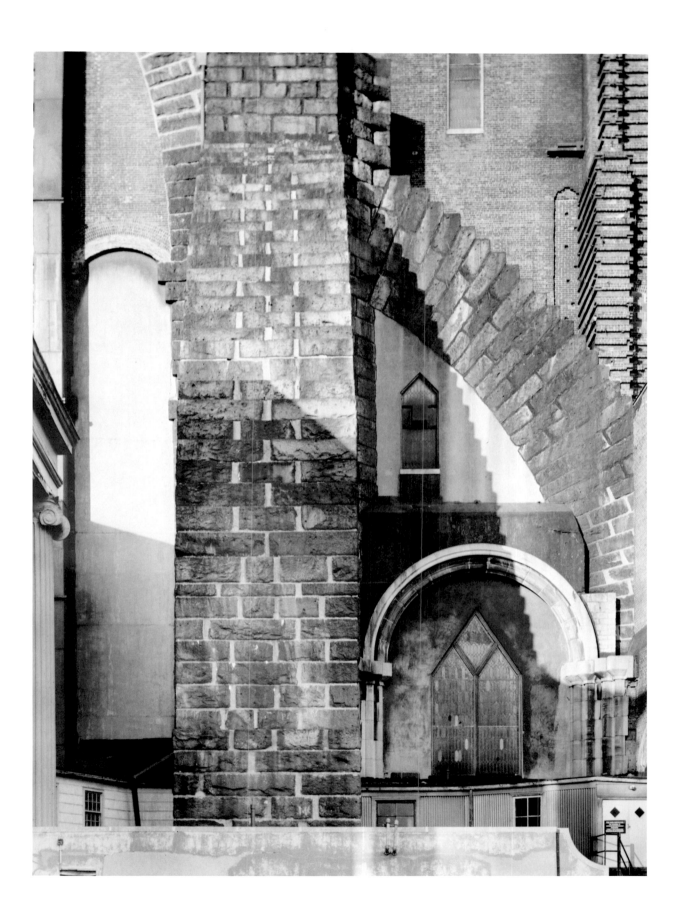

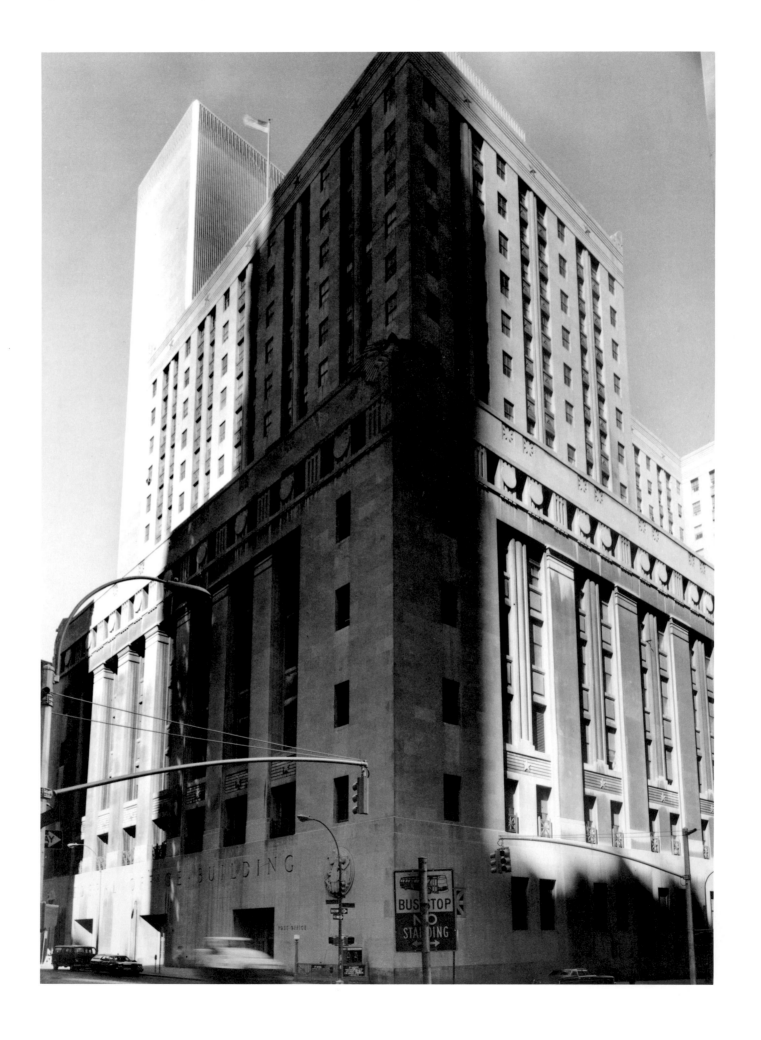

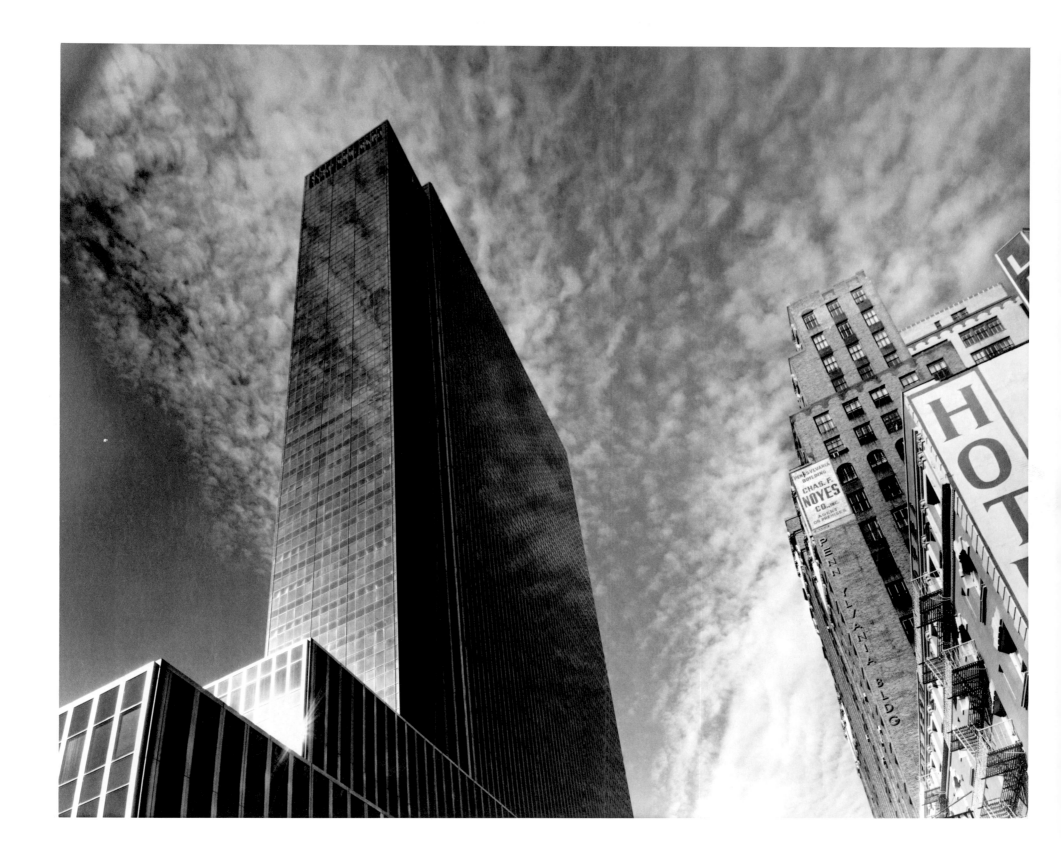

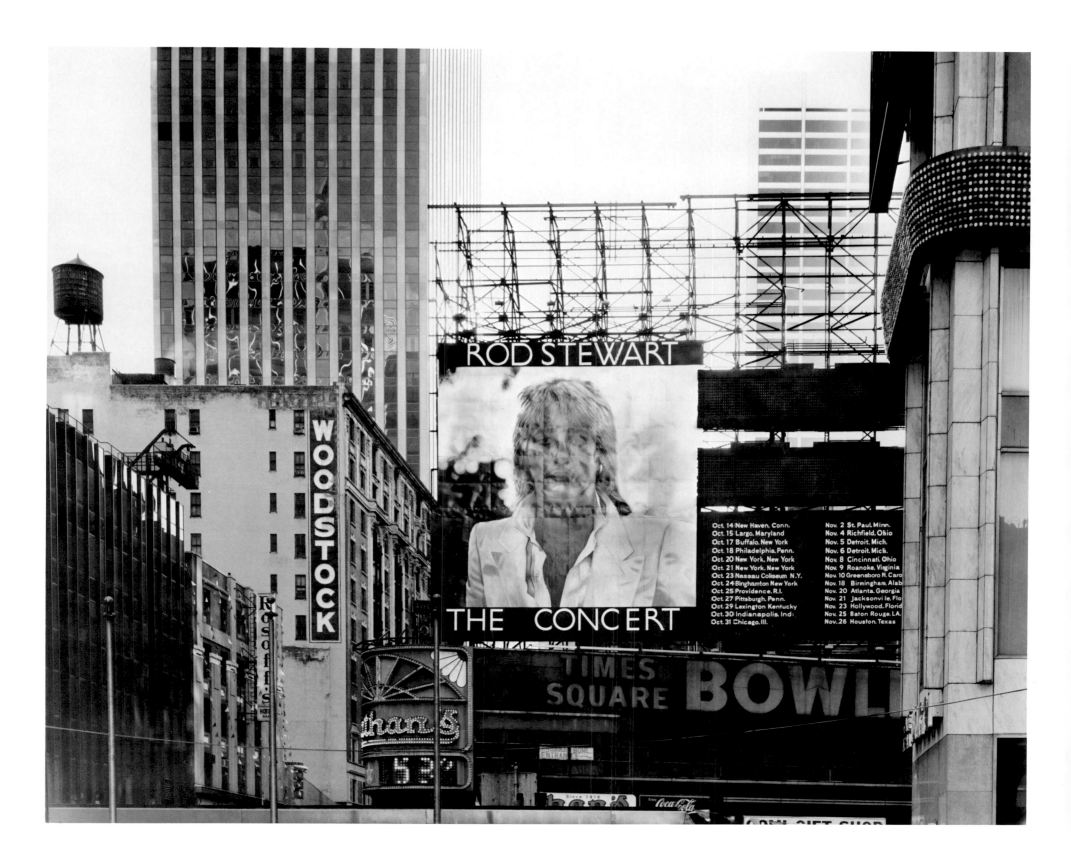

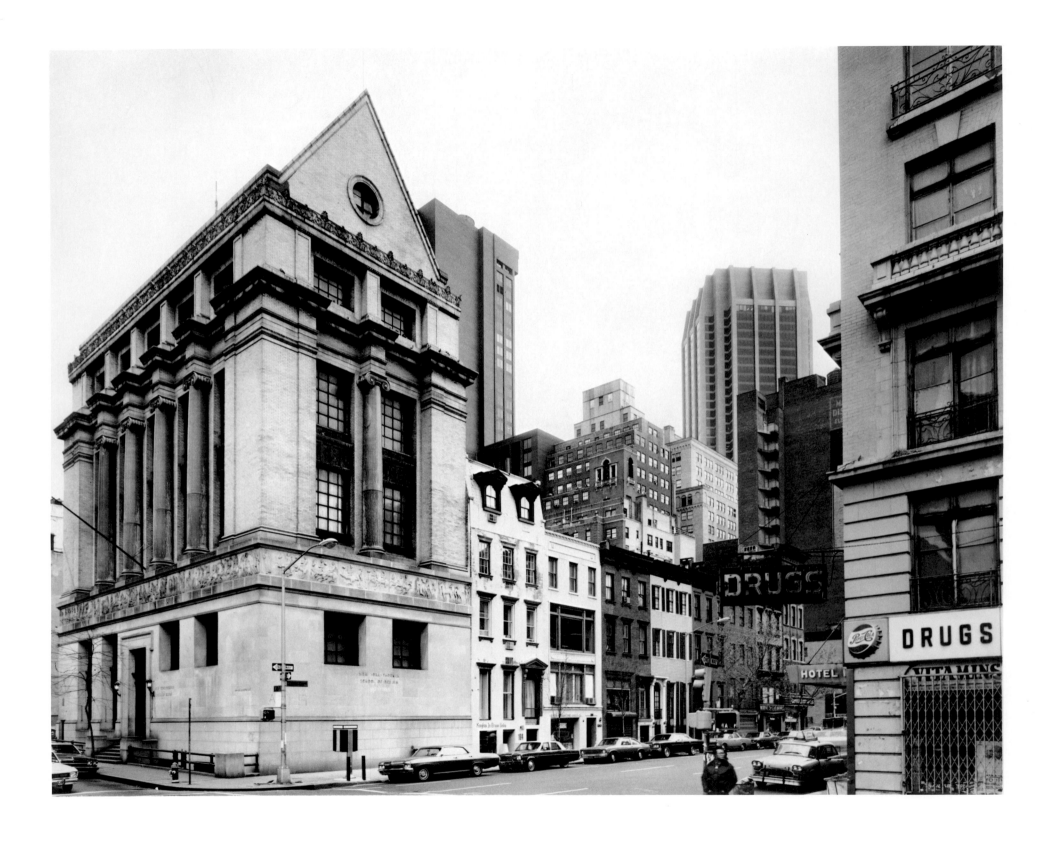

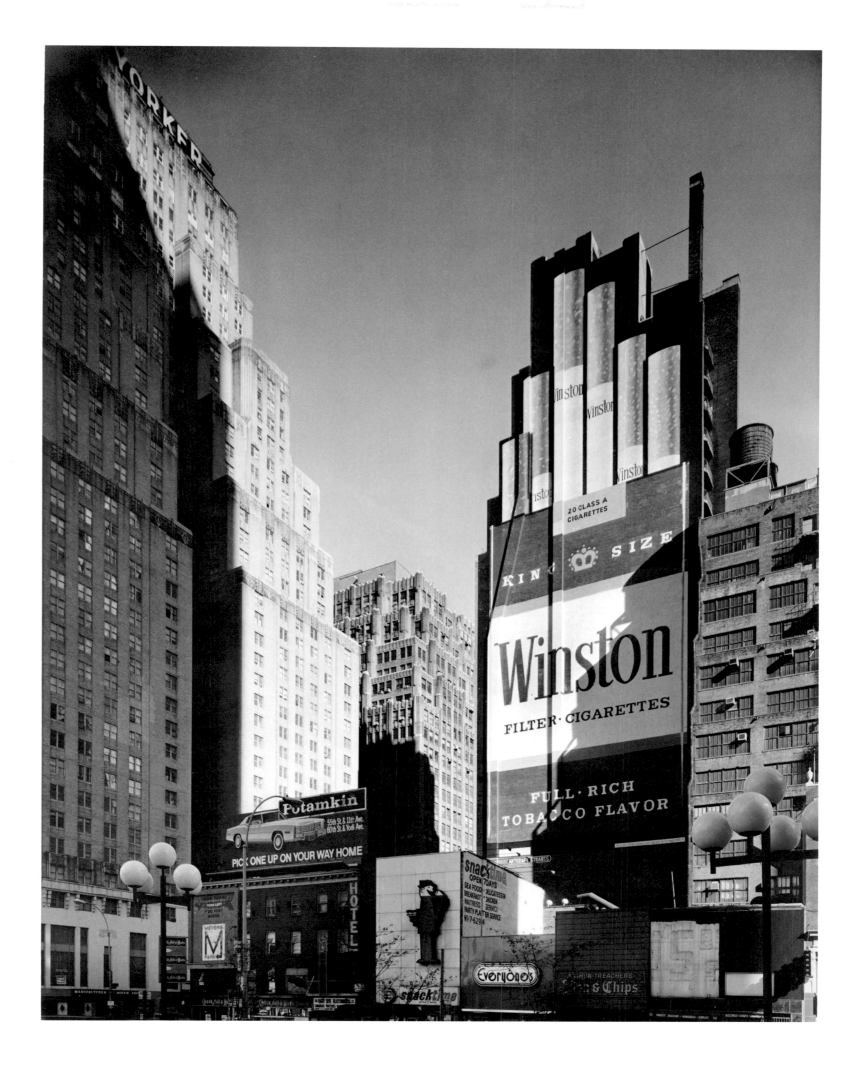

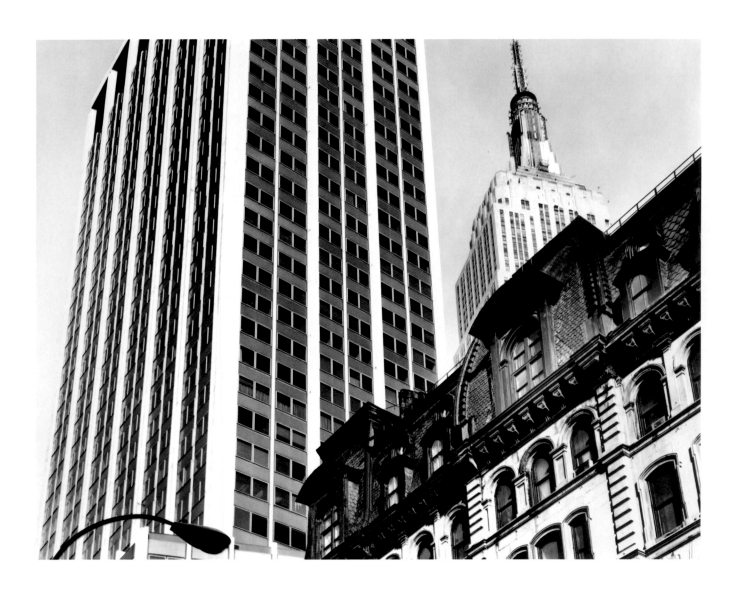

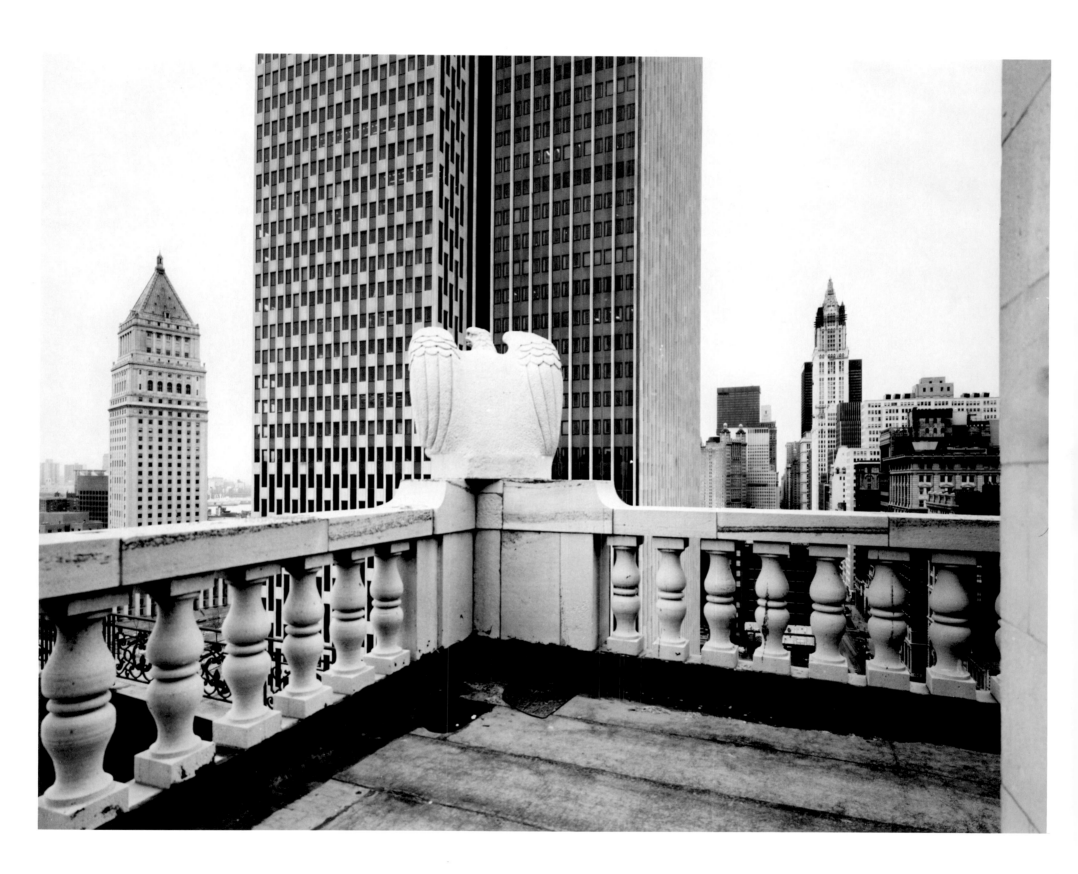

69

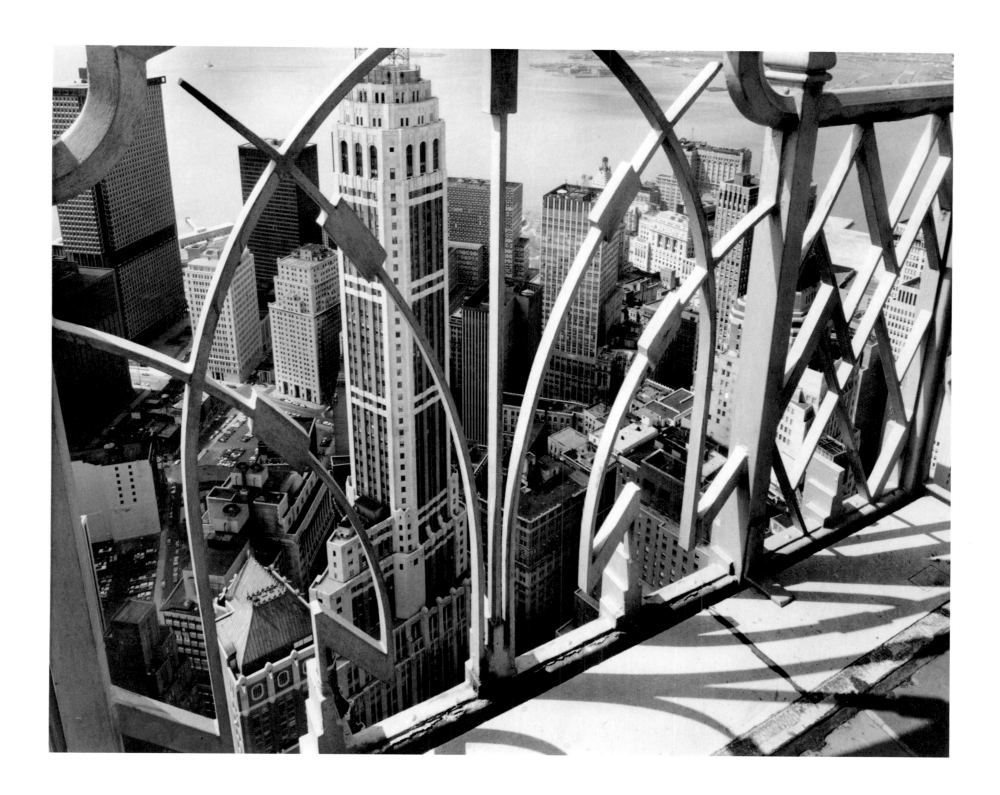

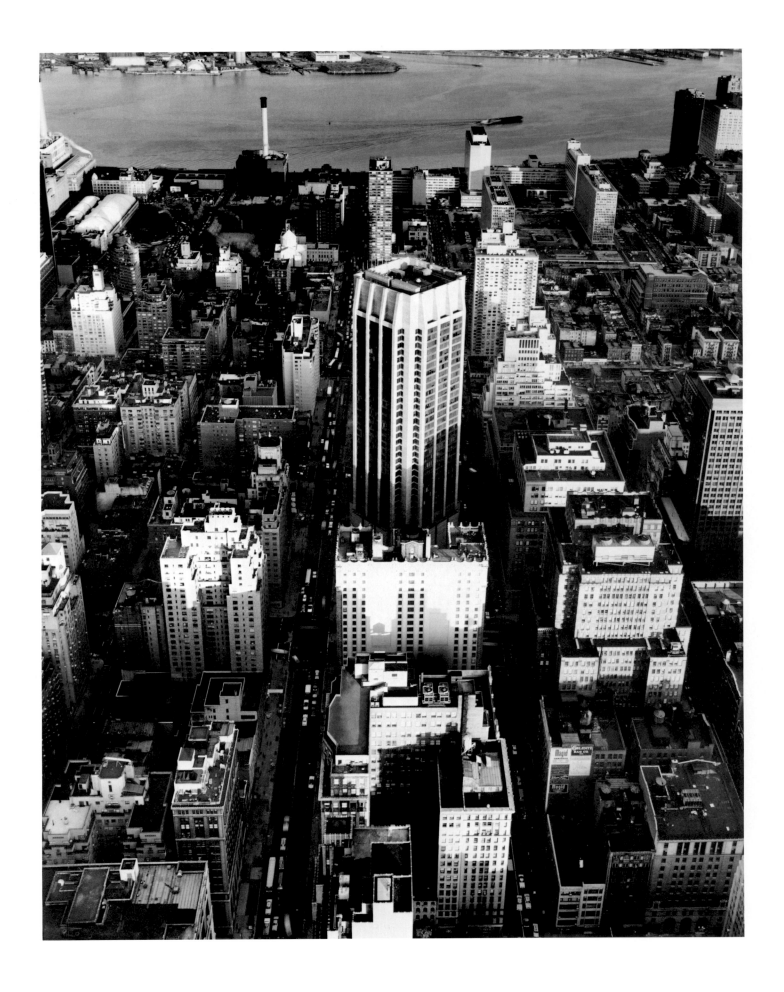

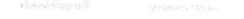

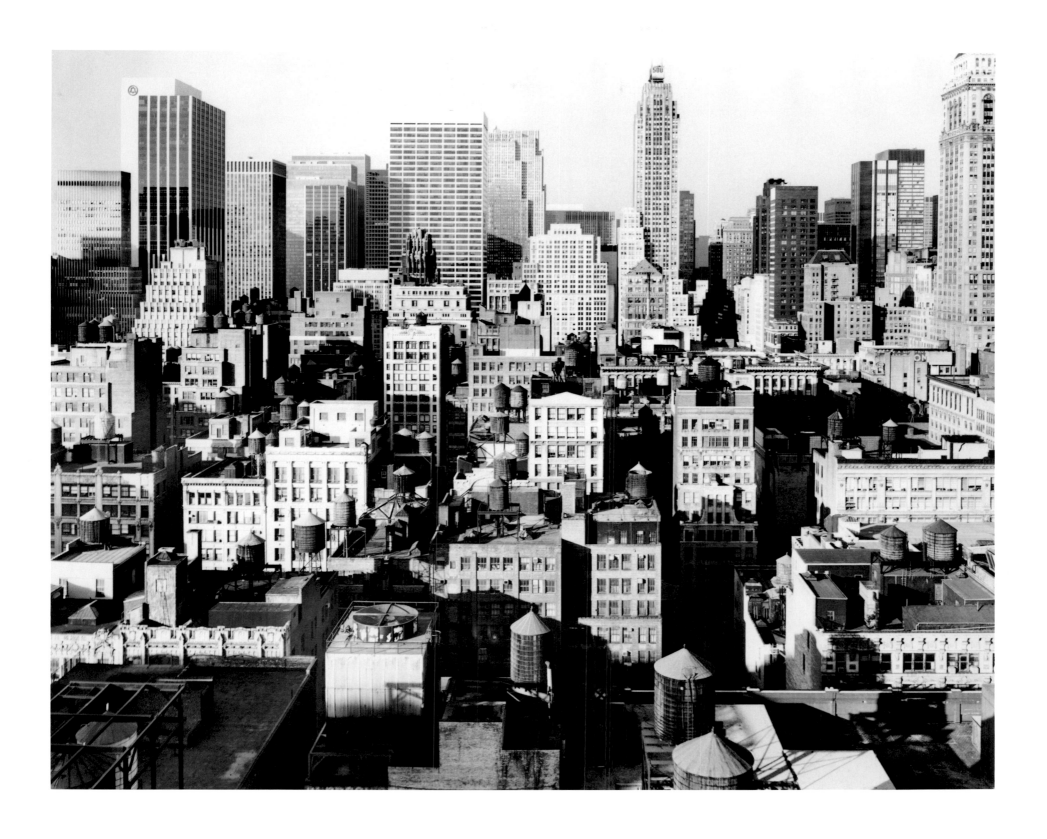

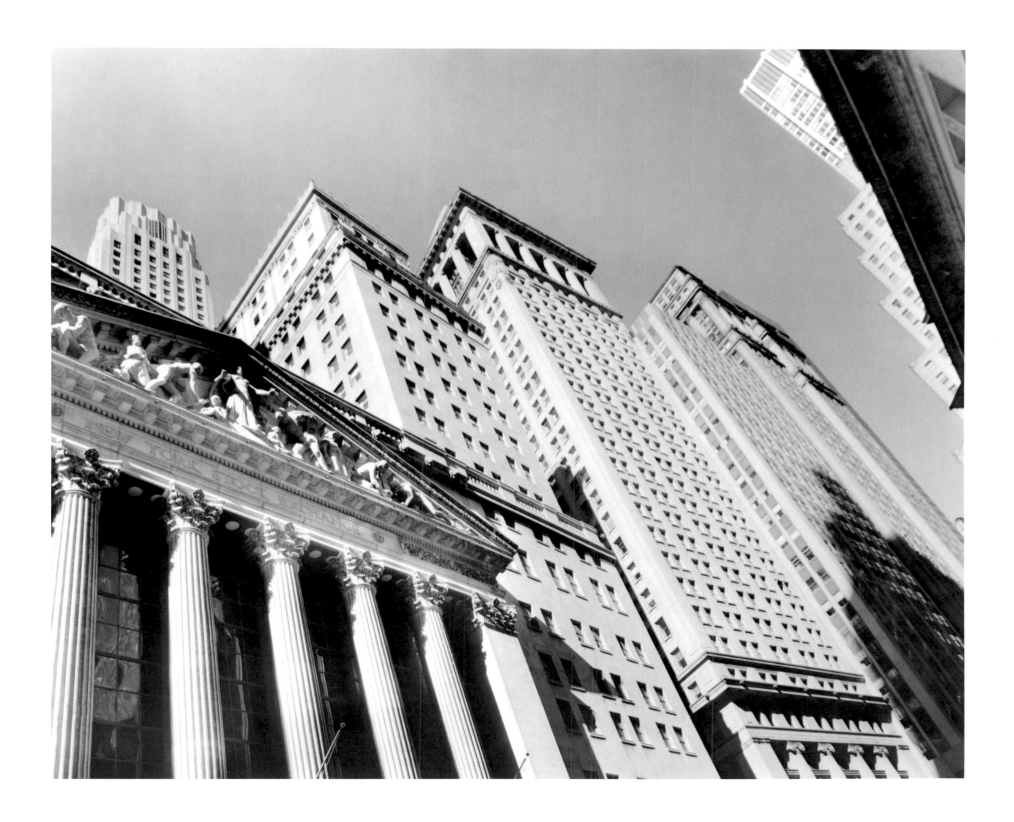

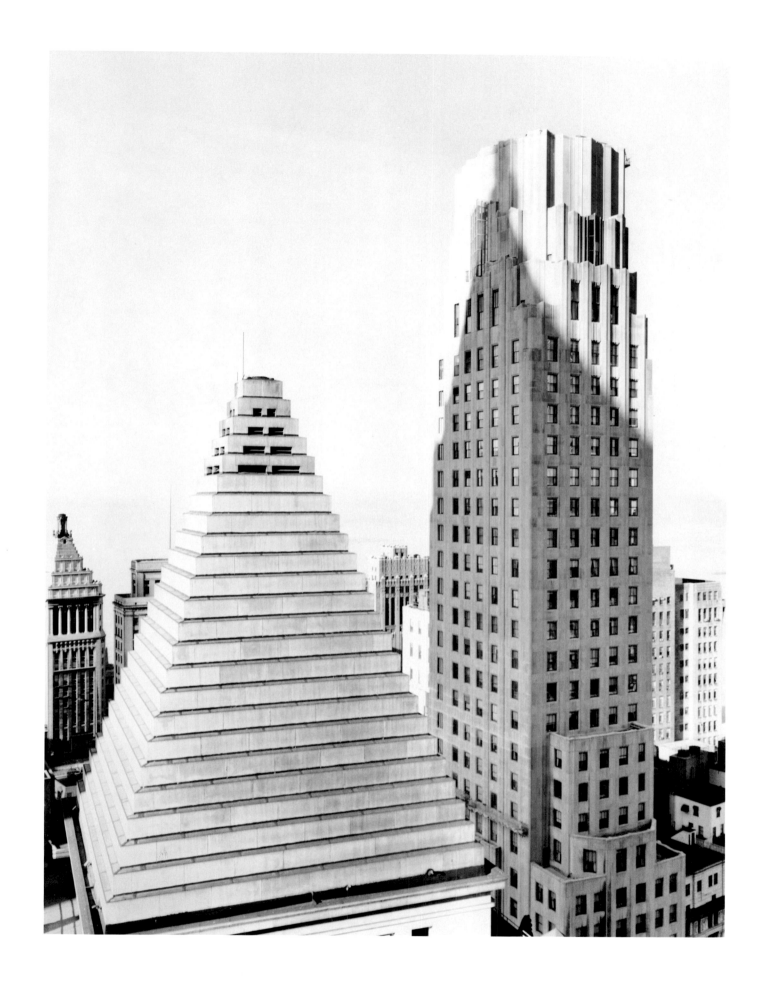

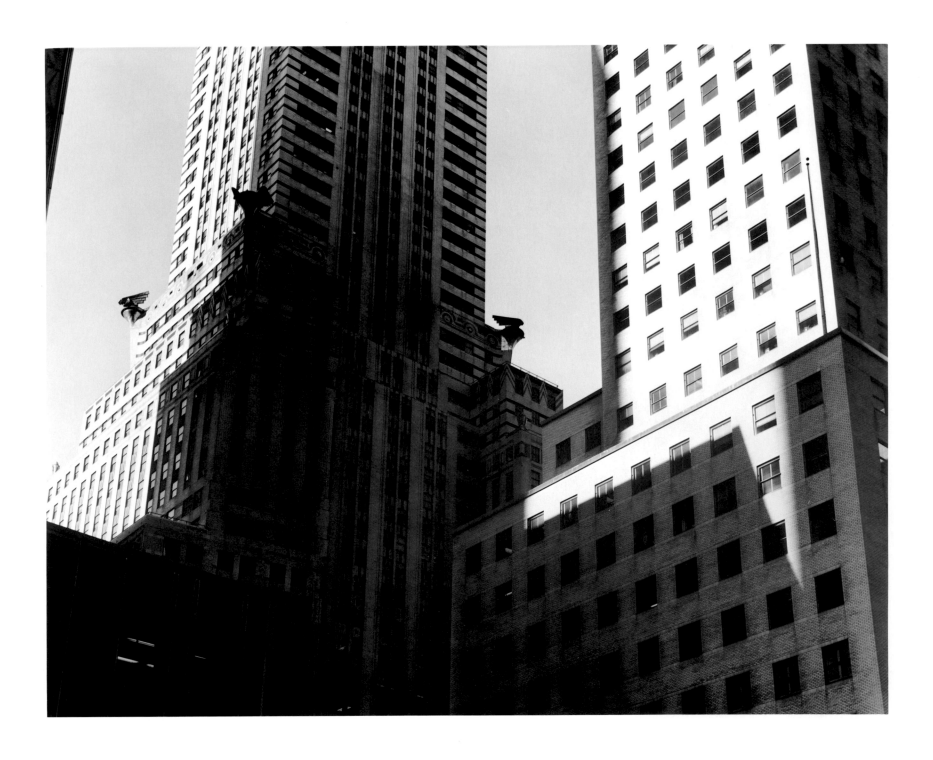

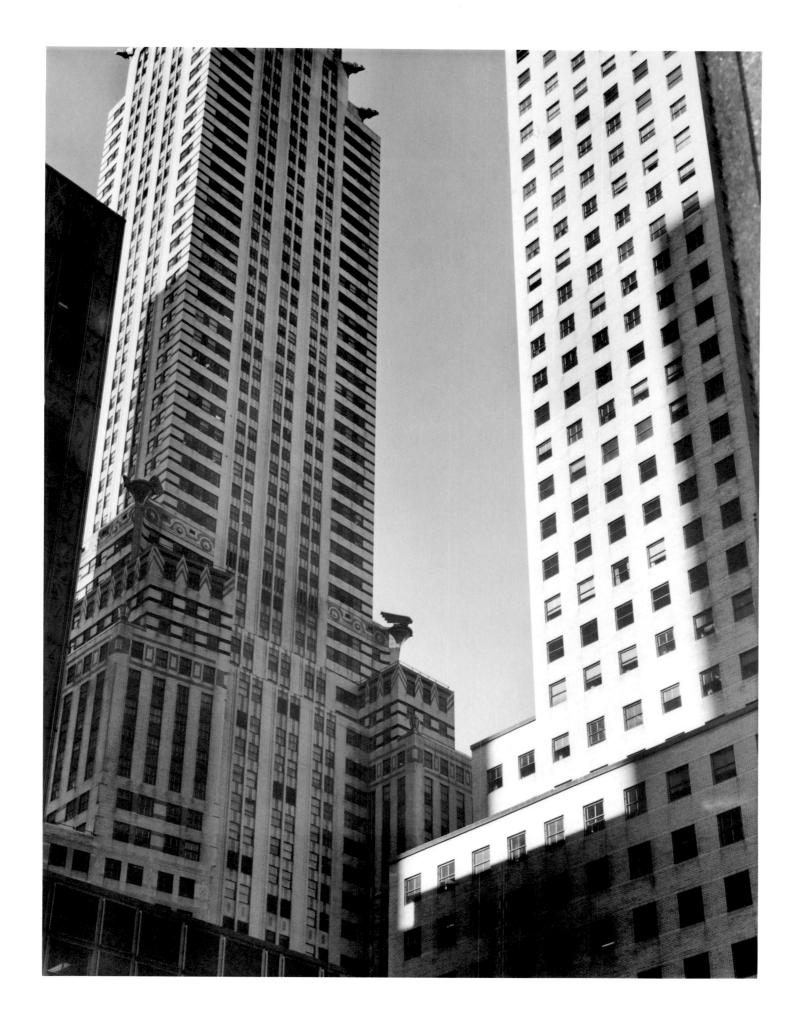

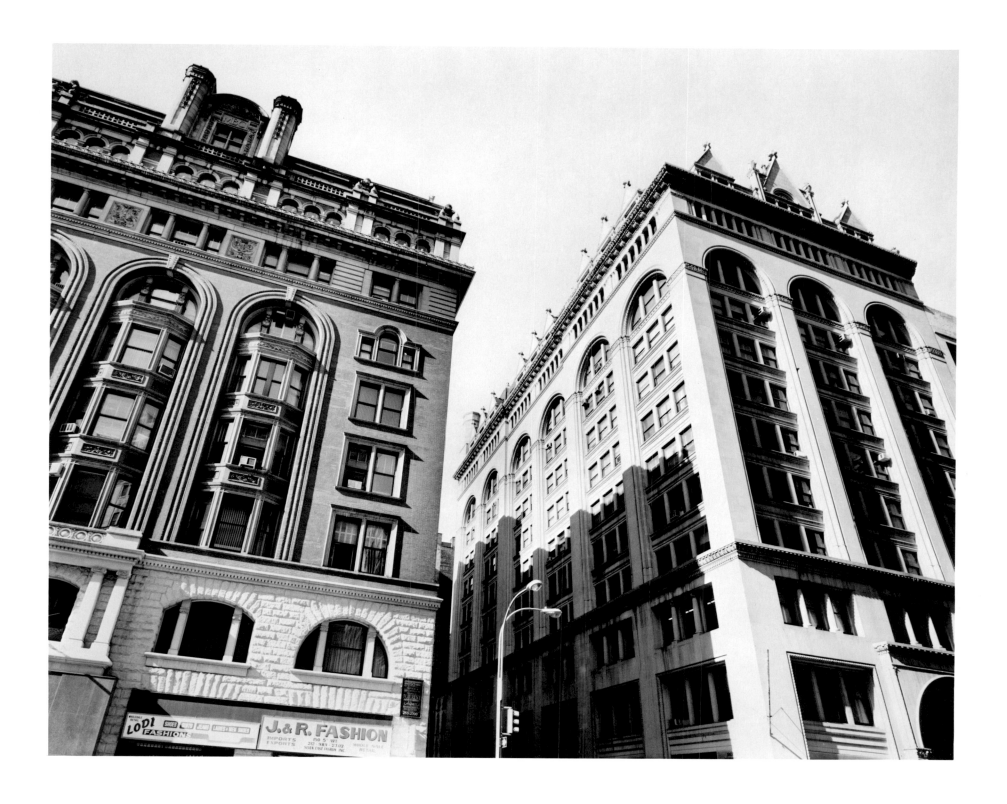

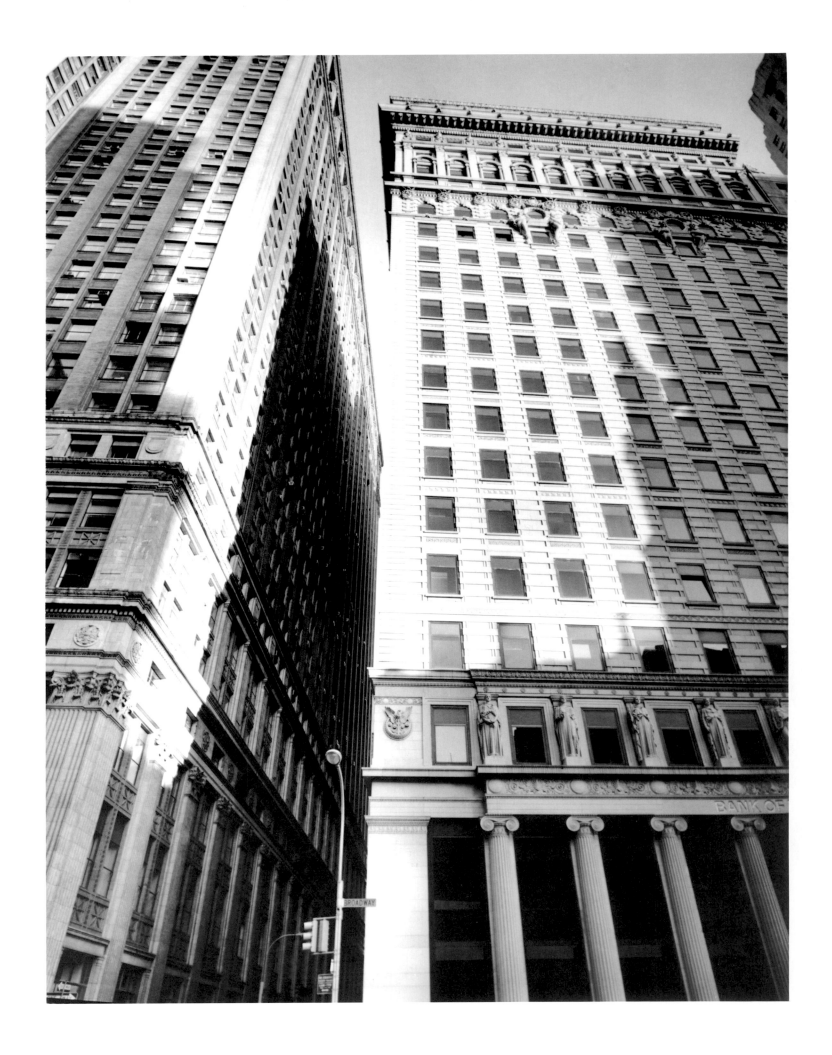

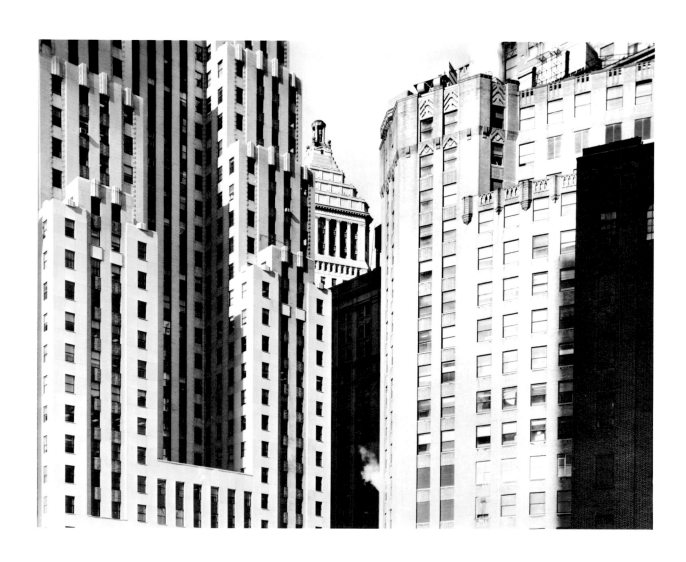

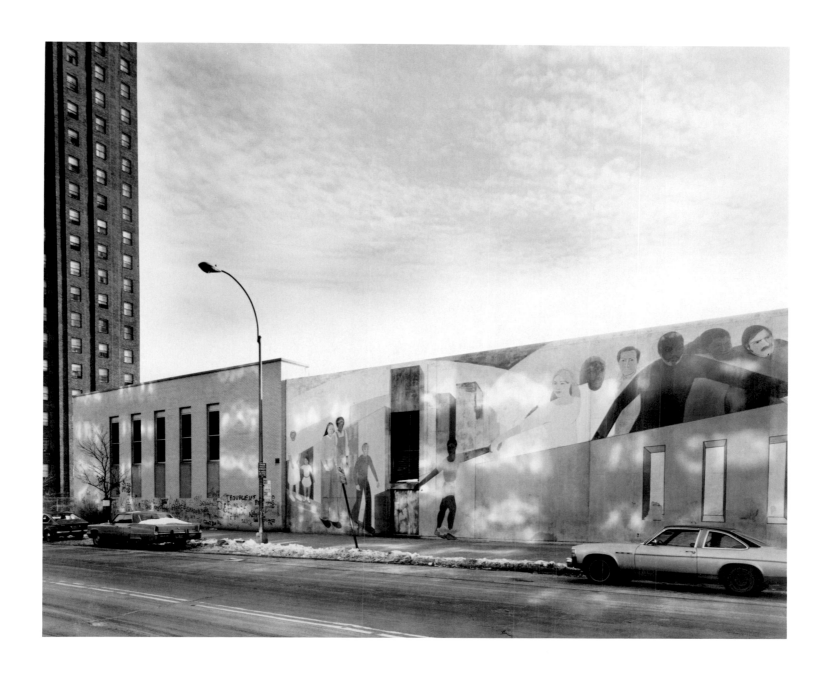

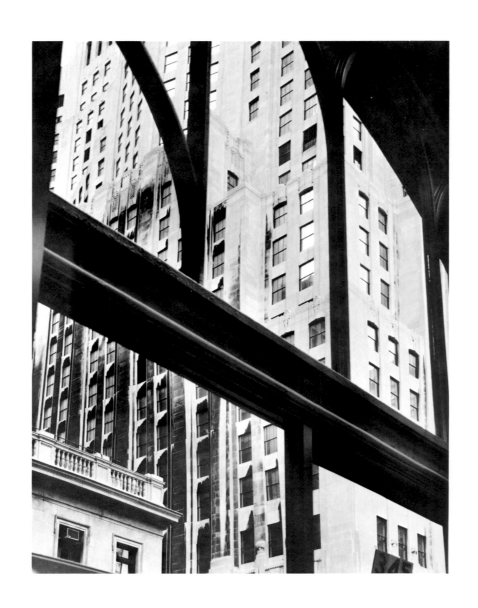

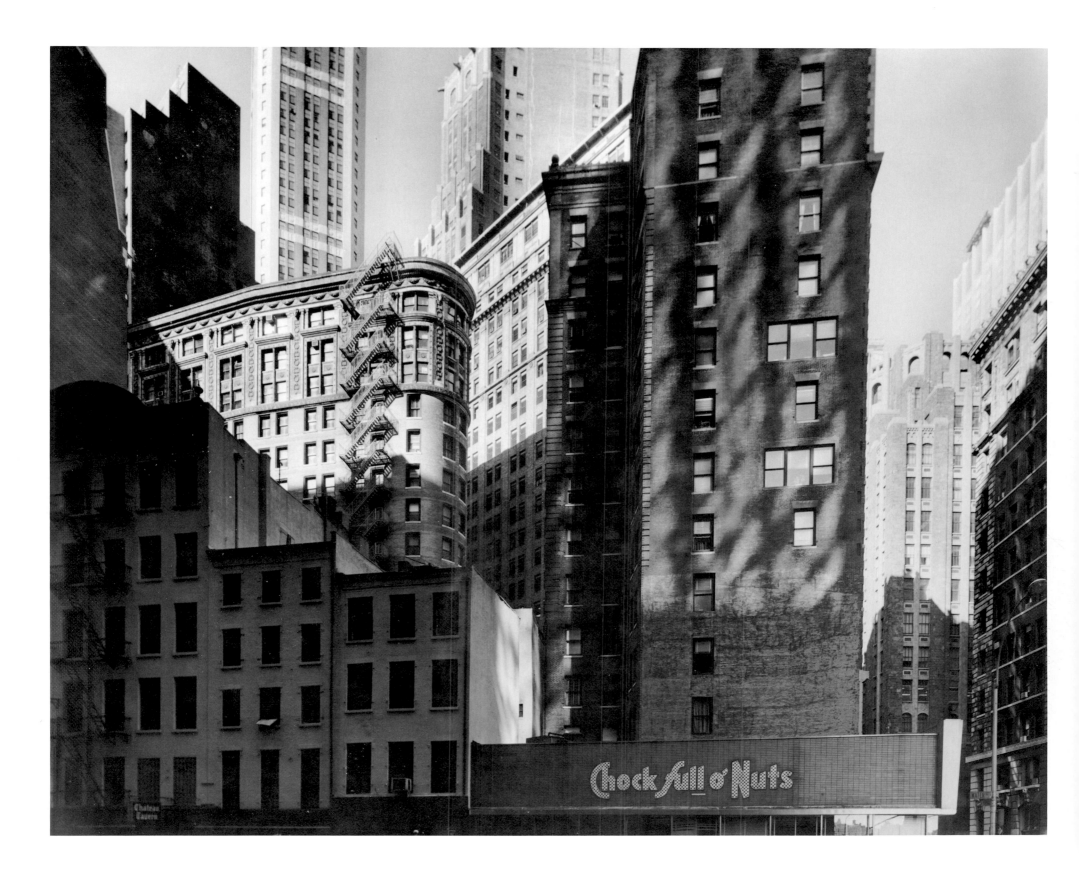

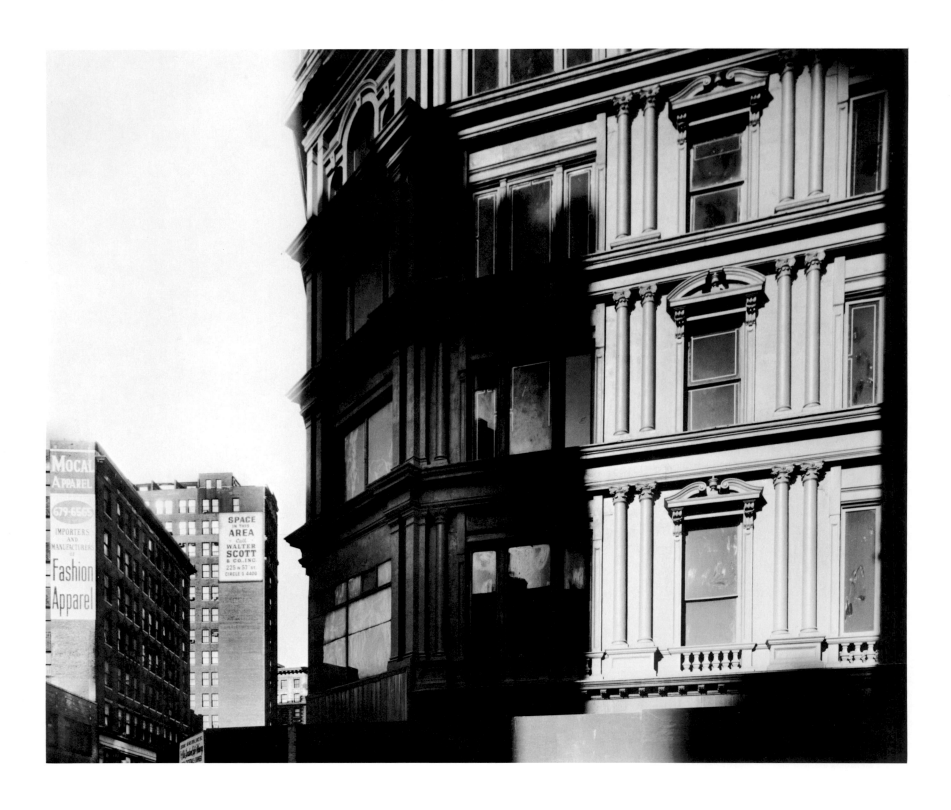

88

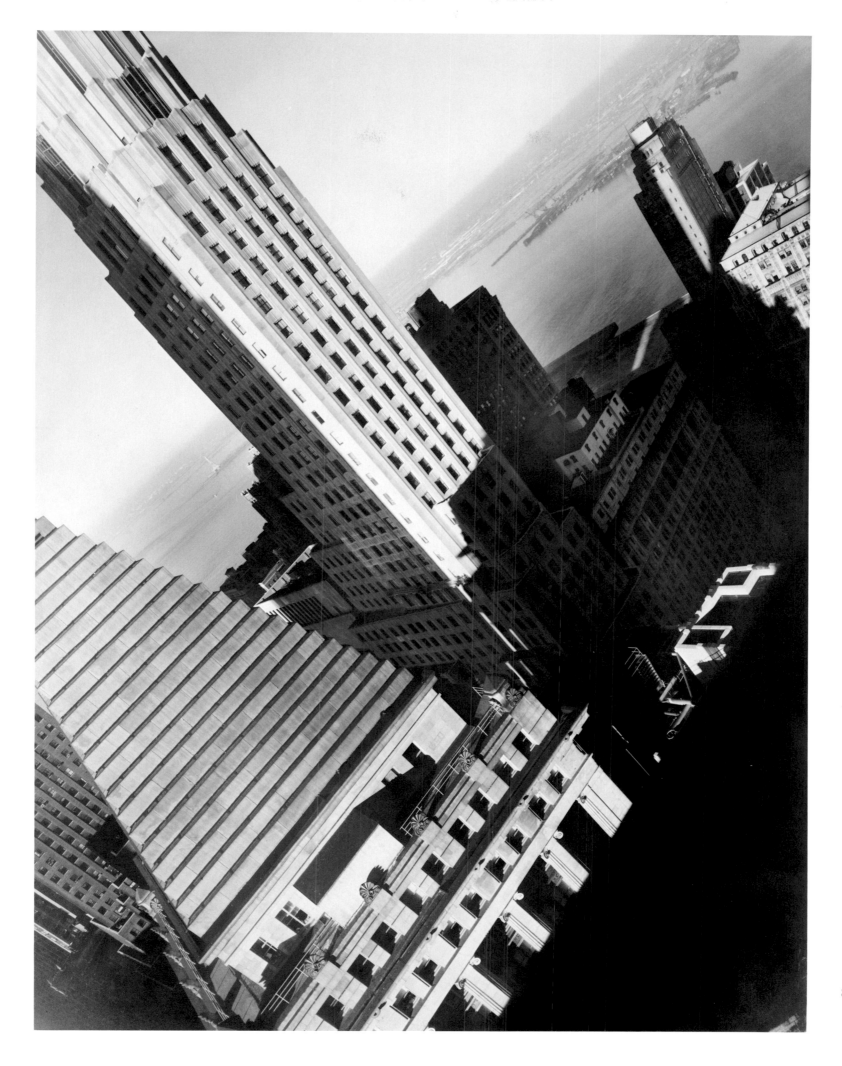

89

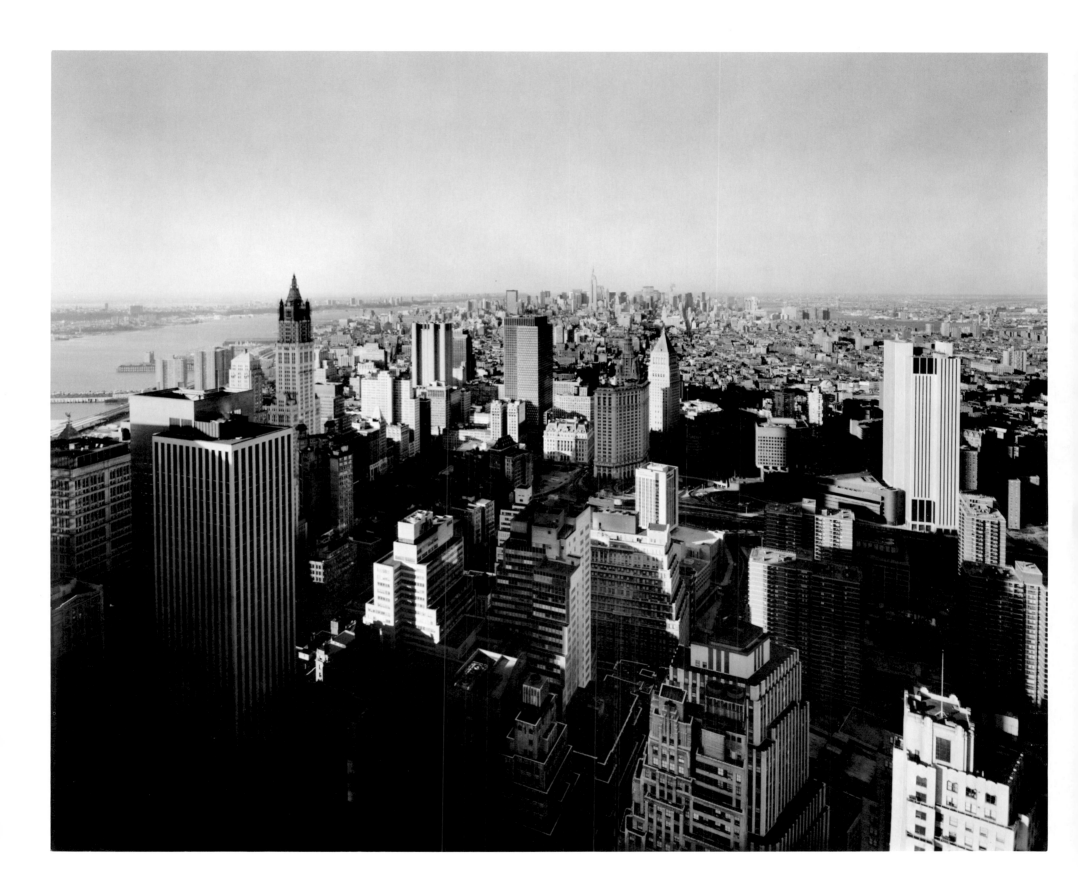

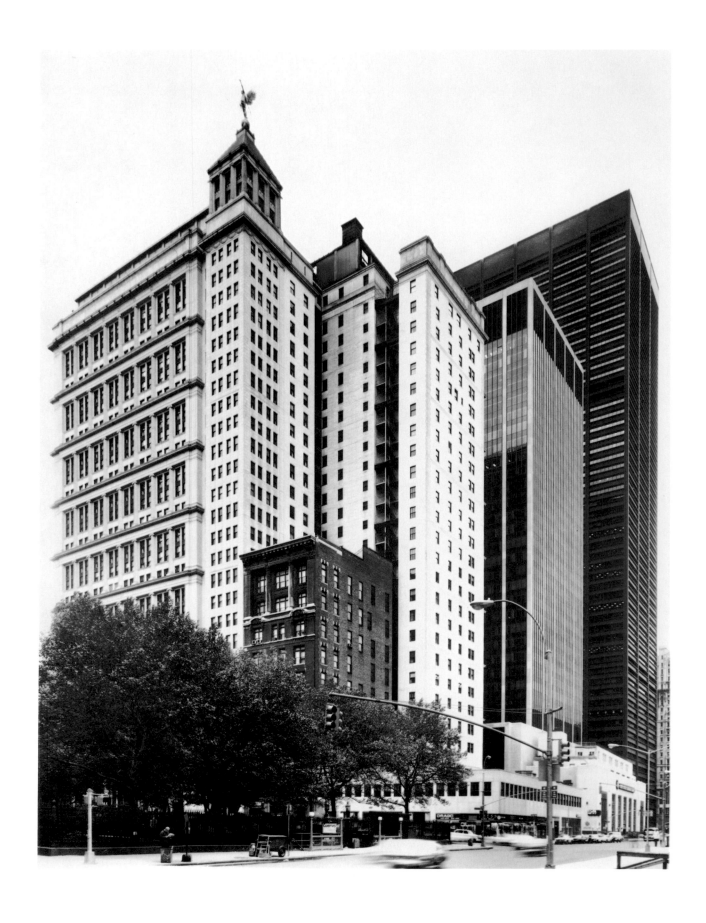

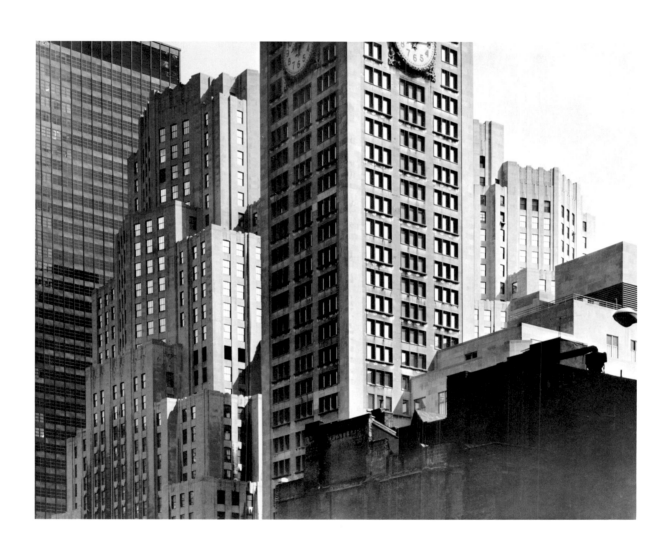

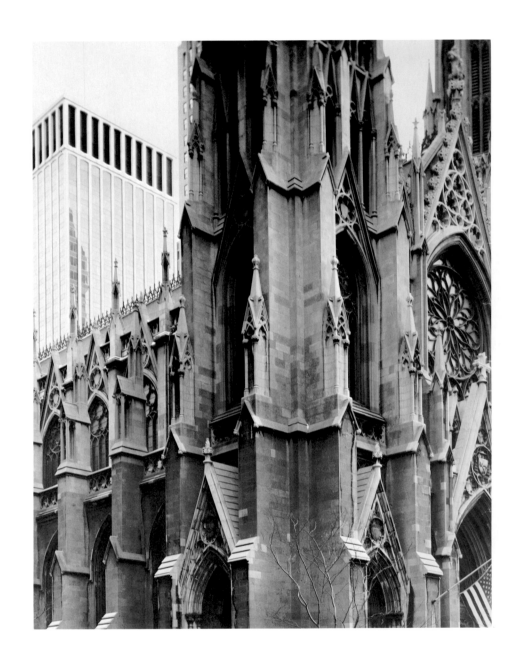

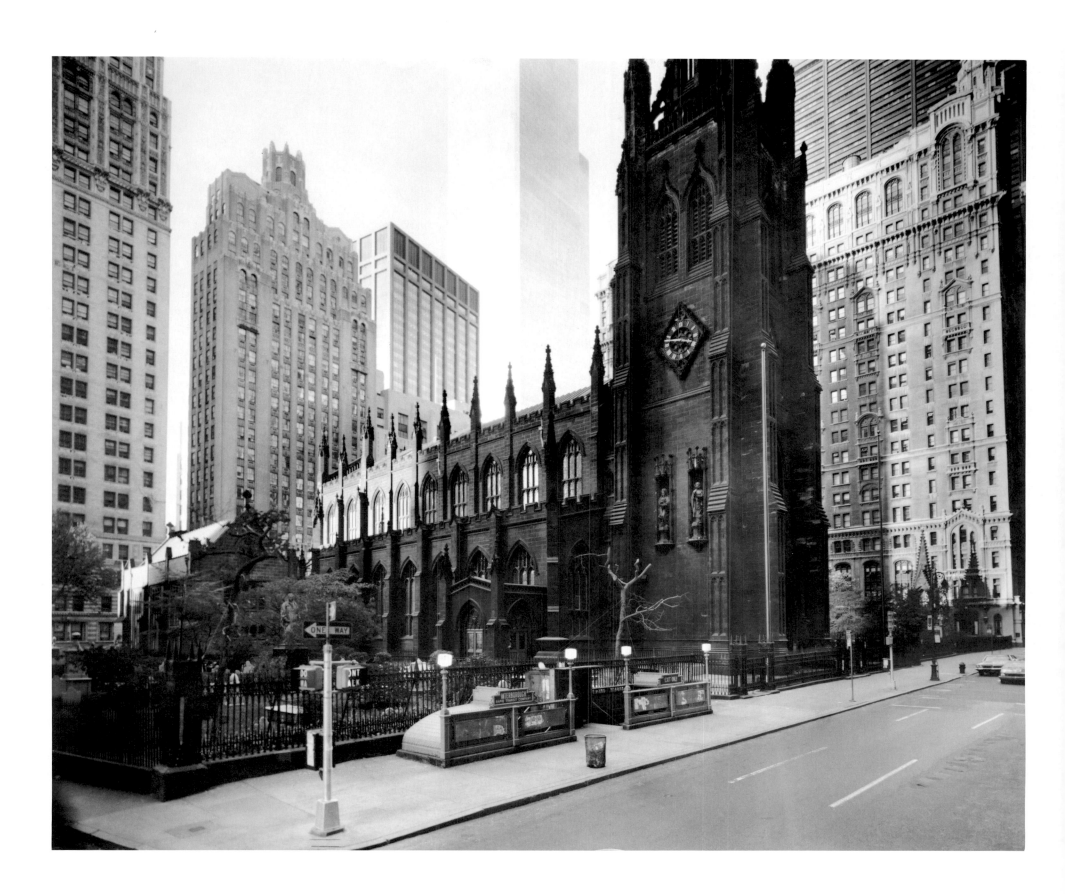

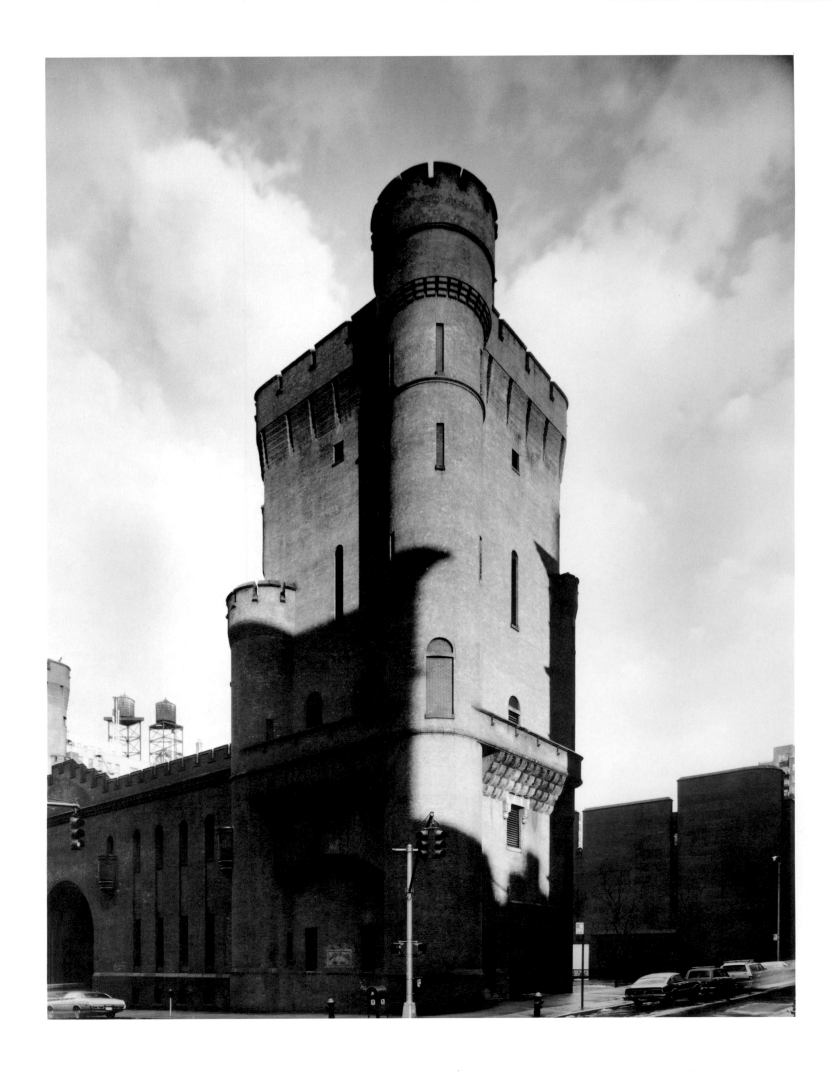

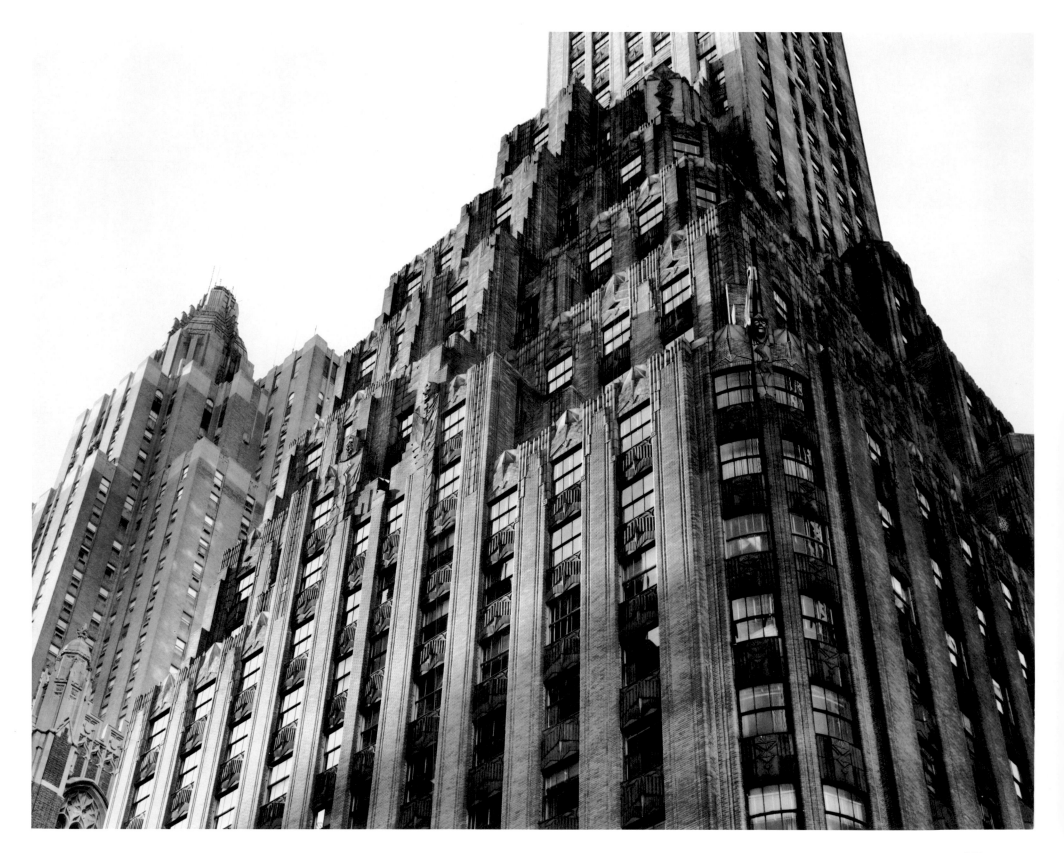

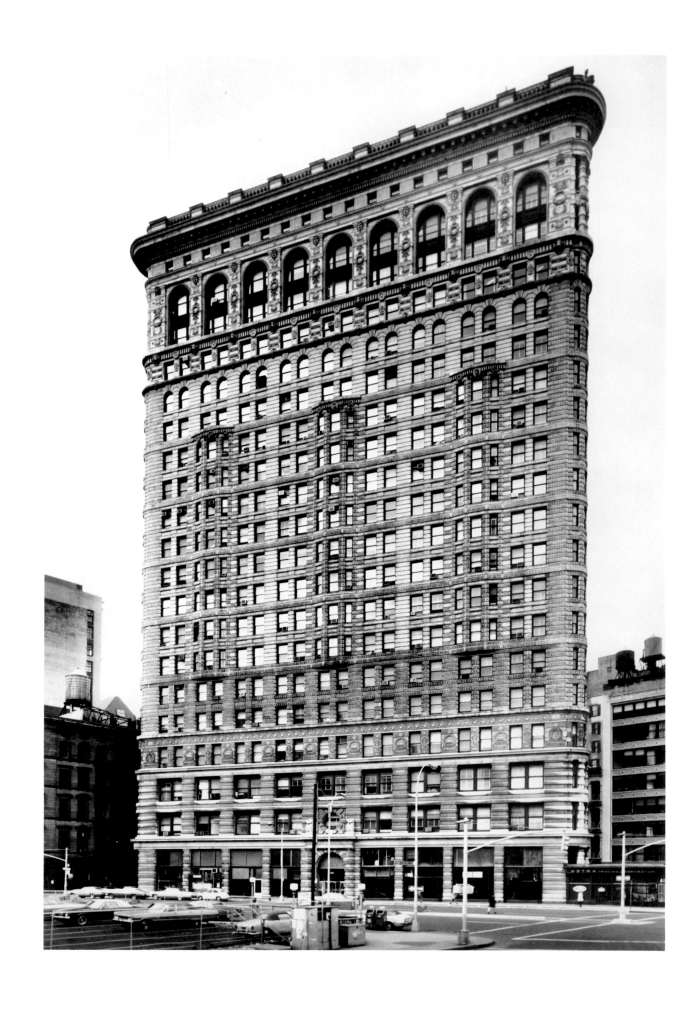

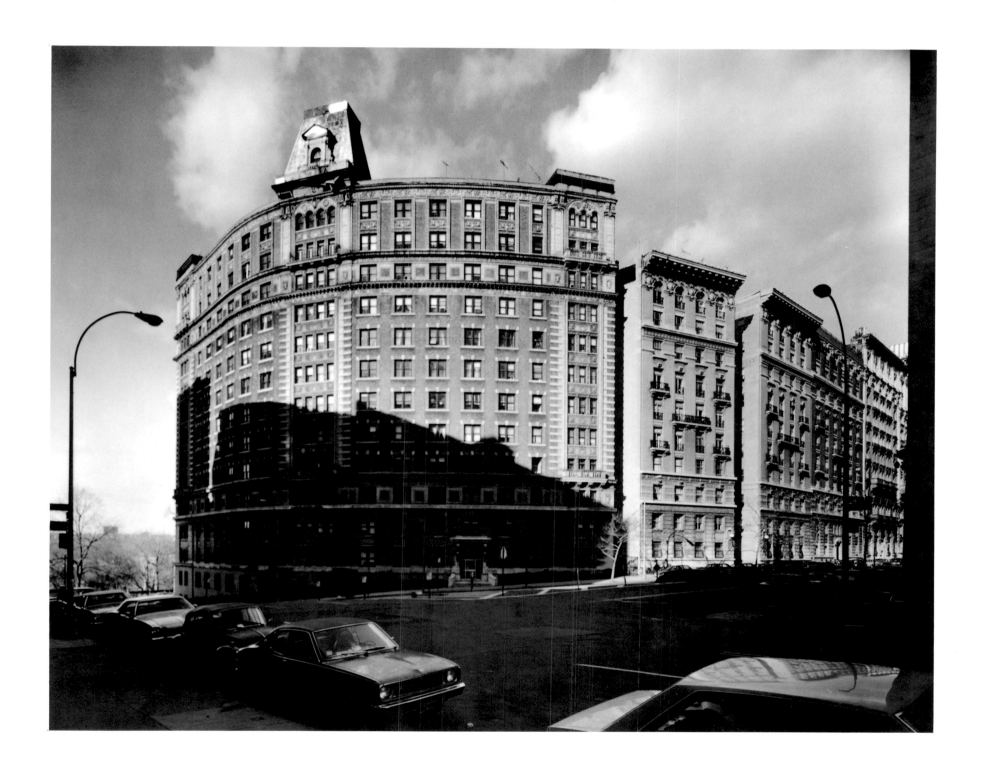

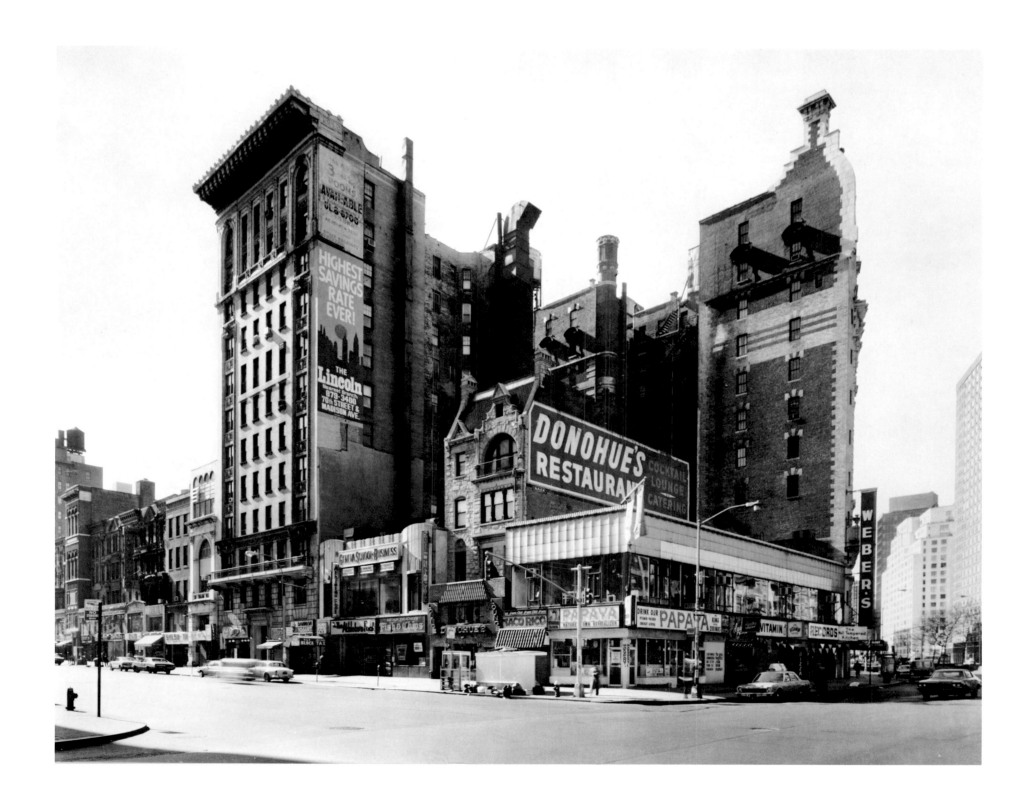

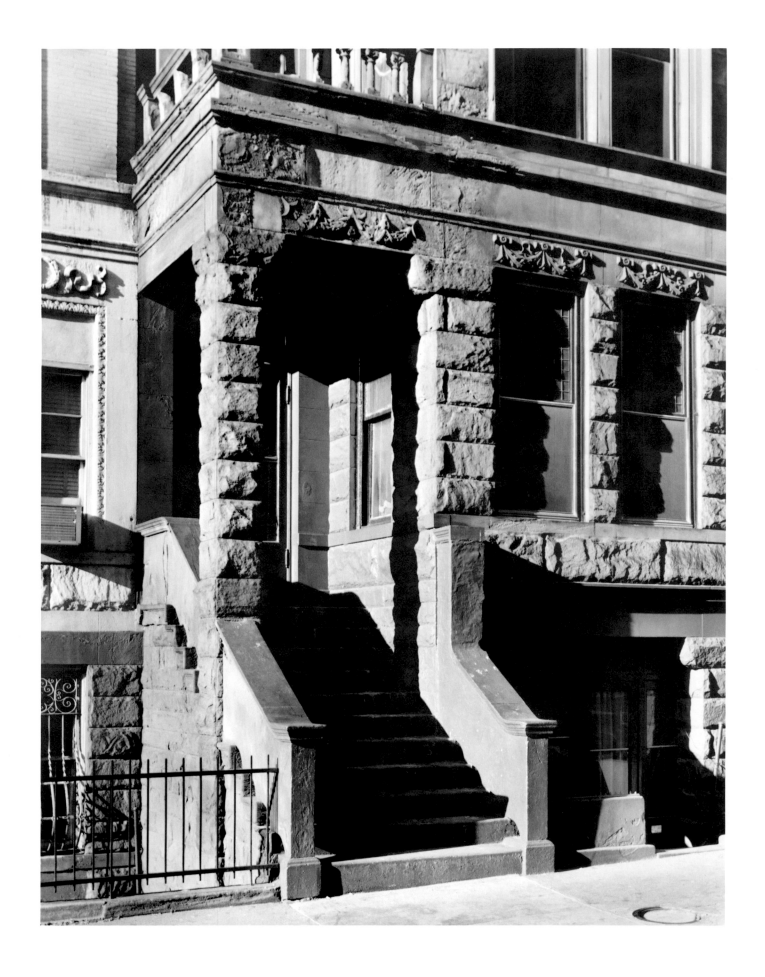

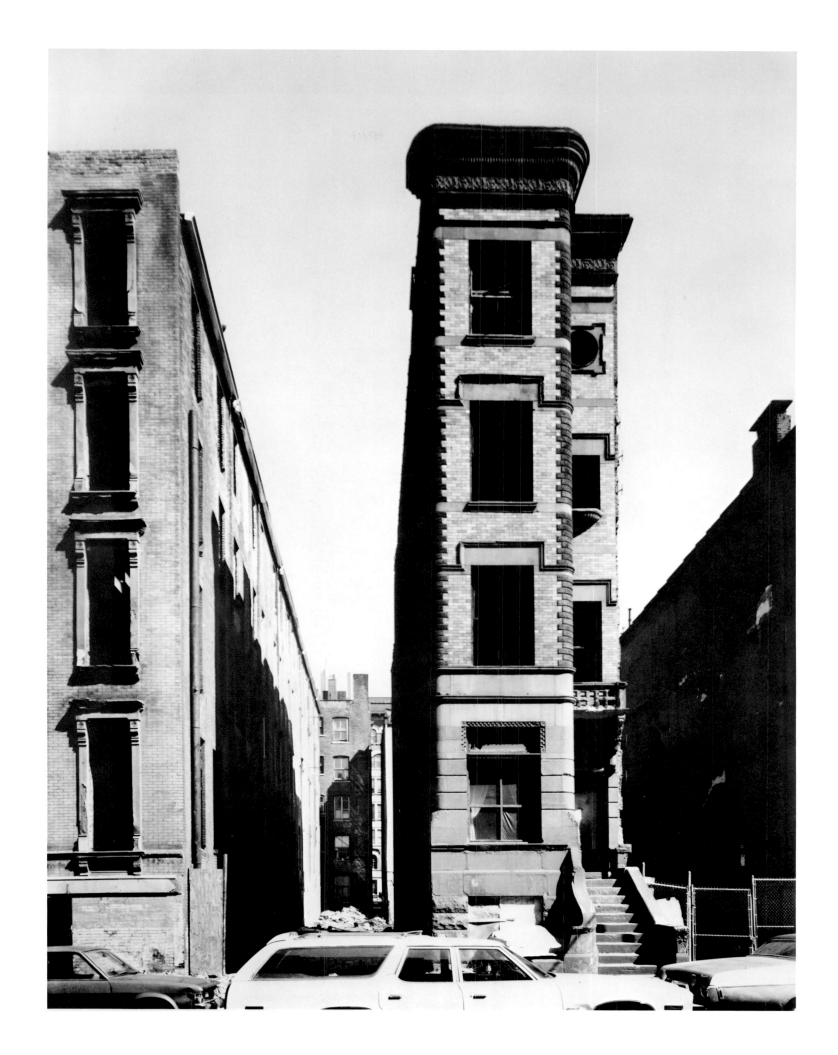

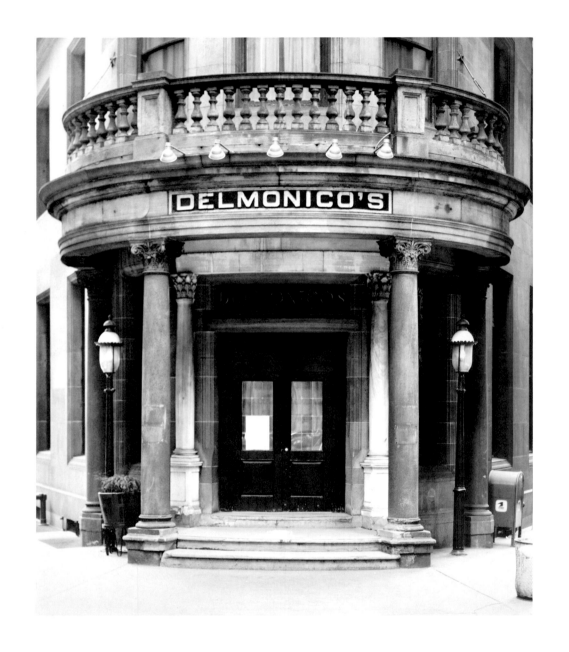

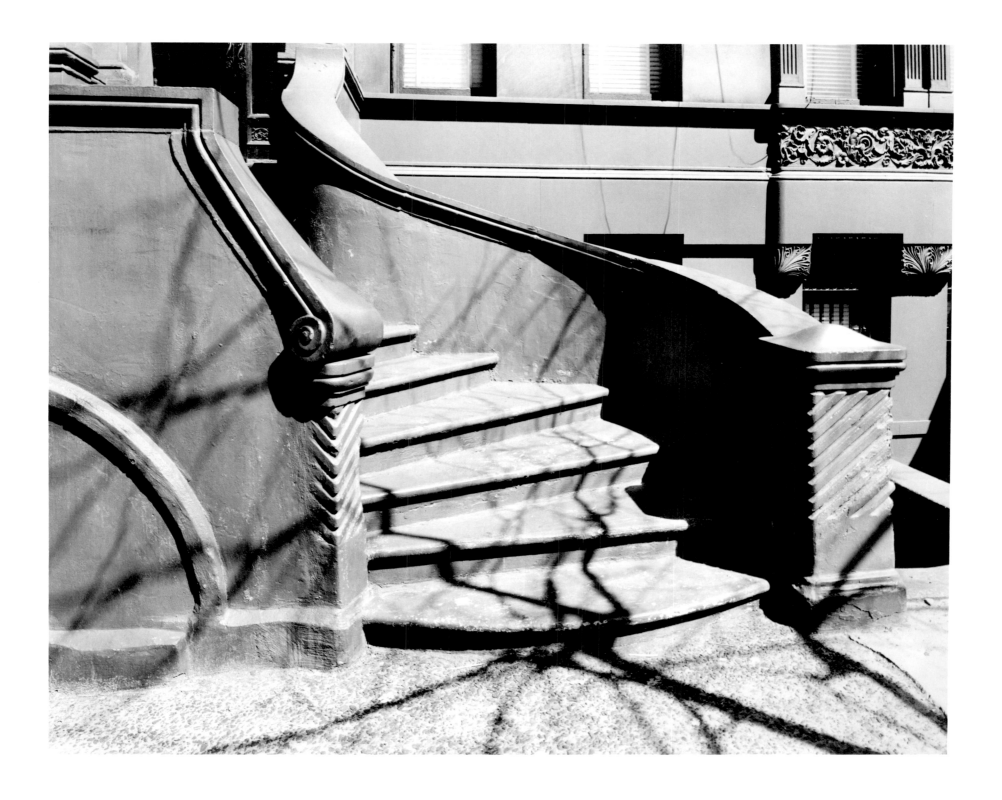

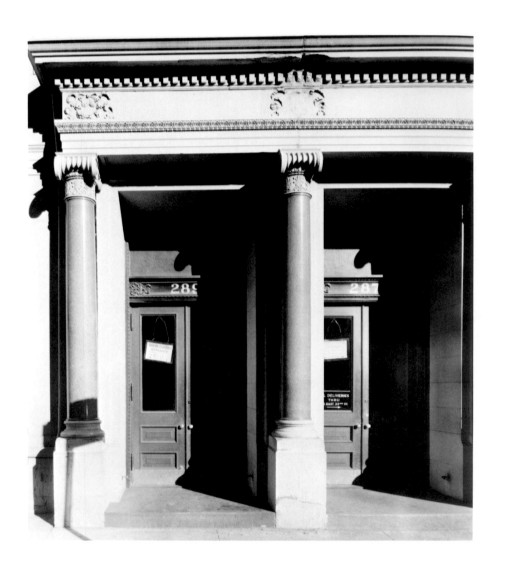

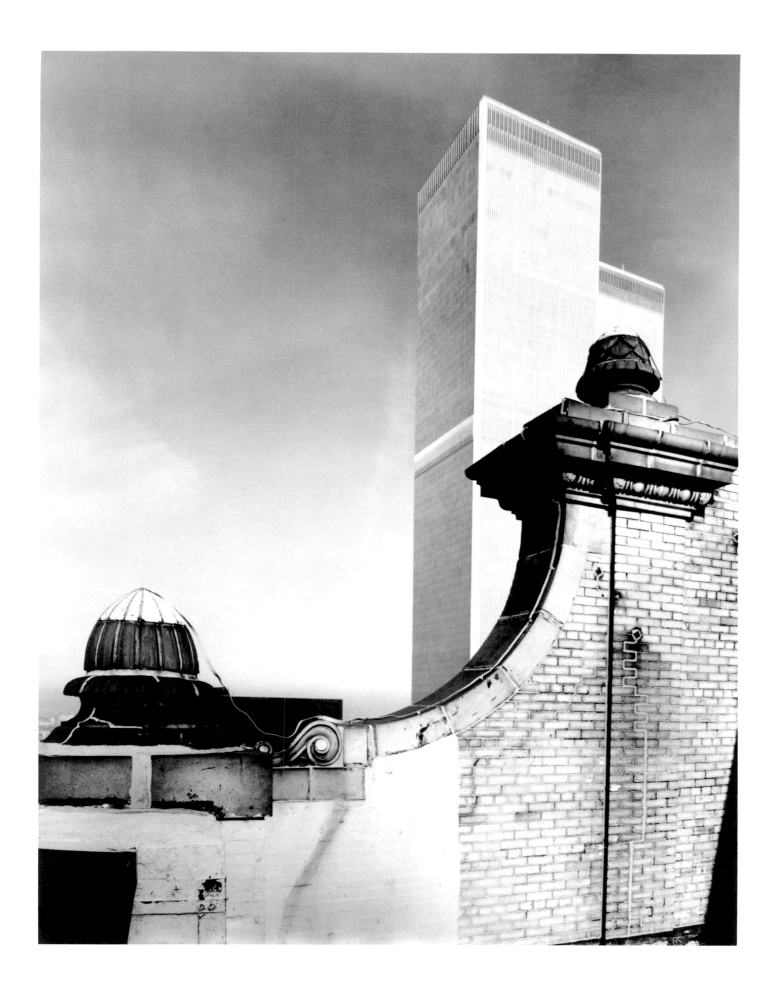

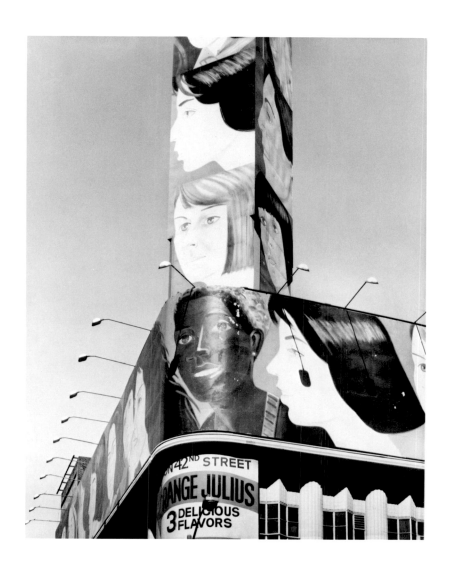

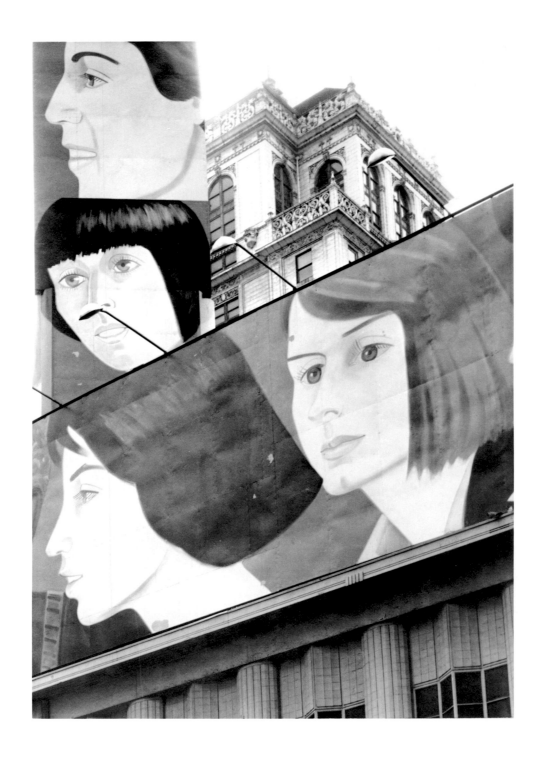

110

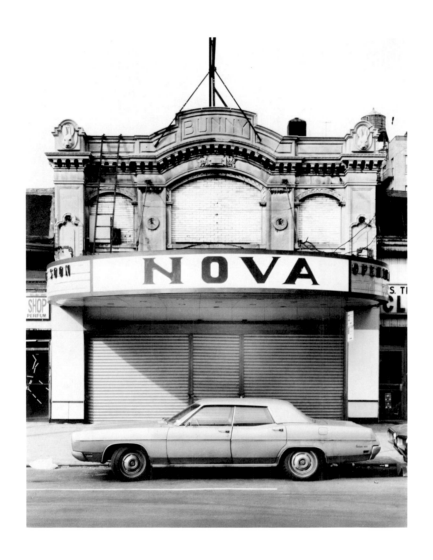

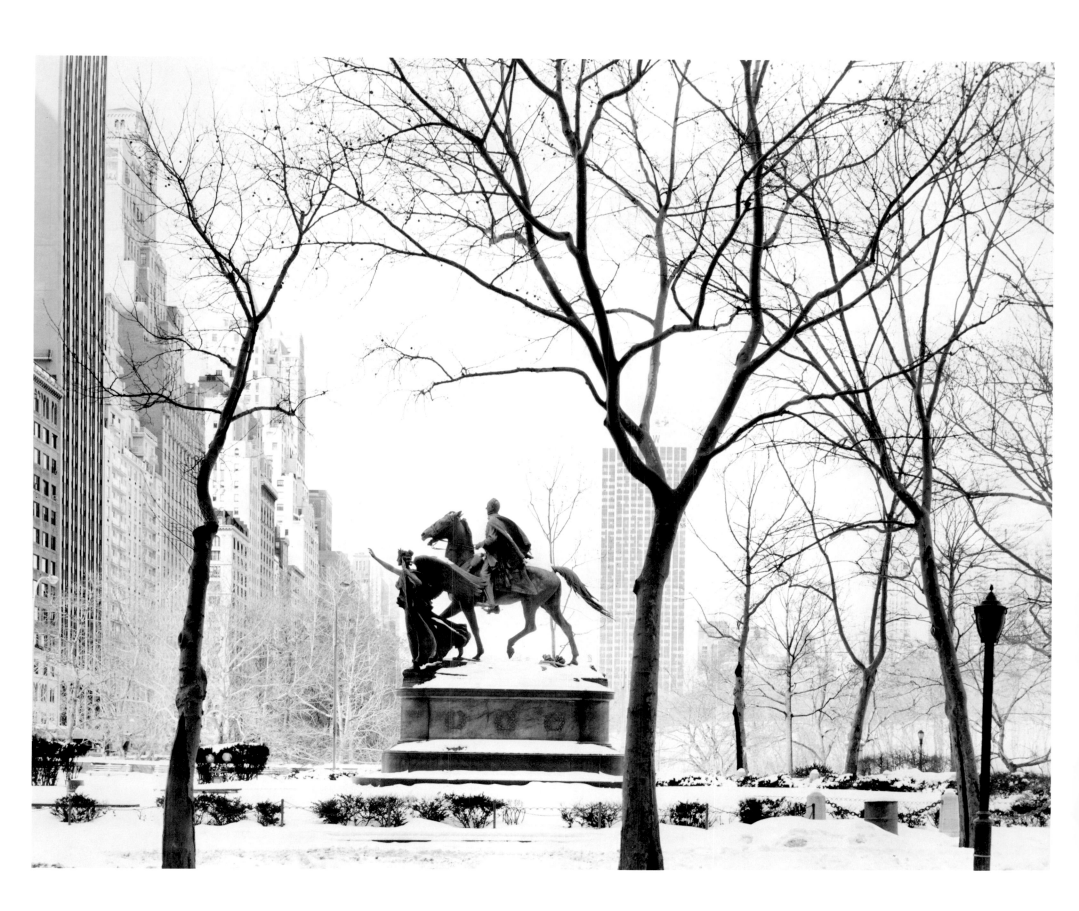

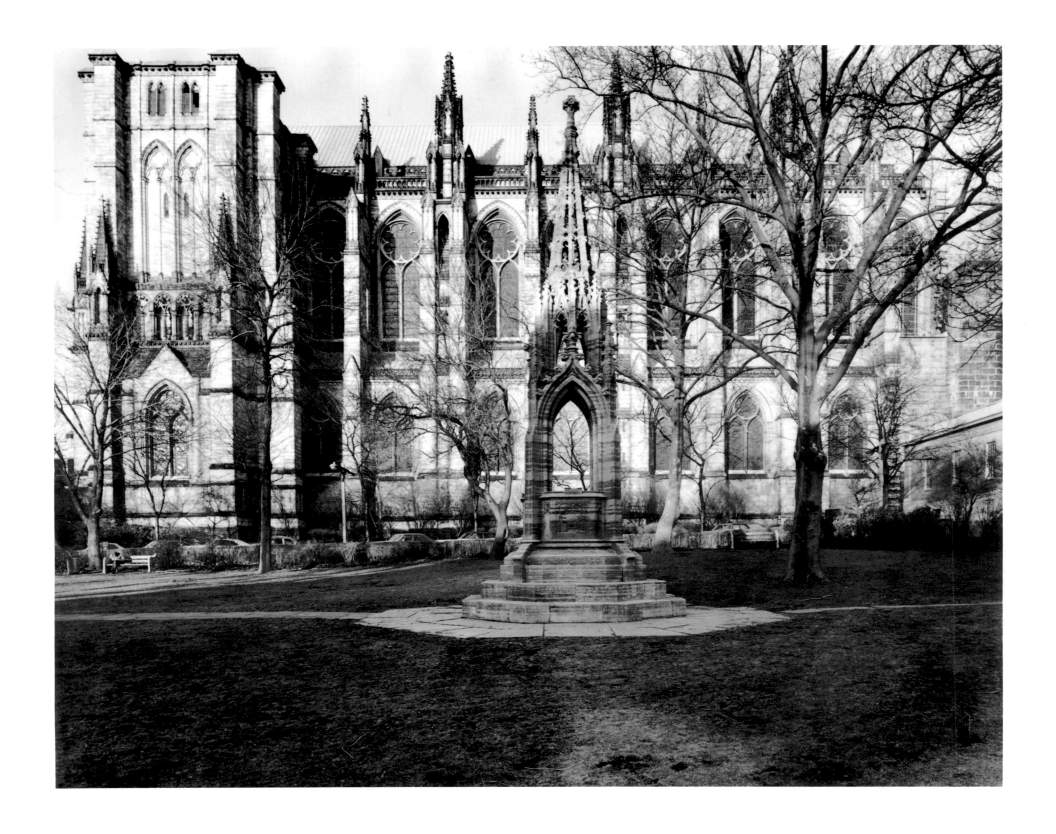

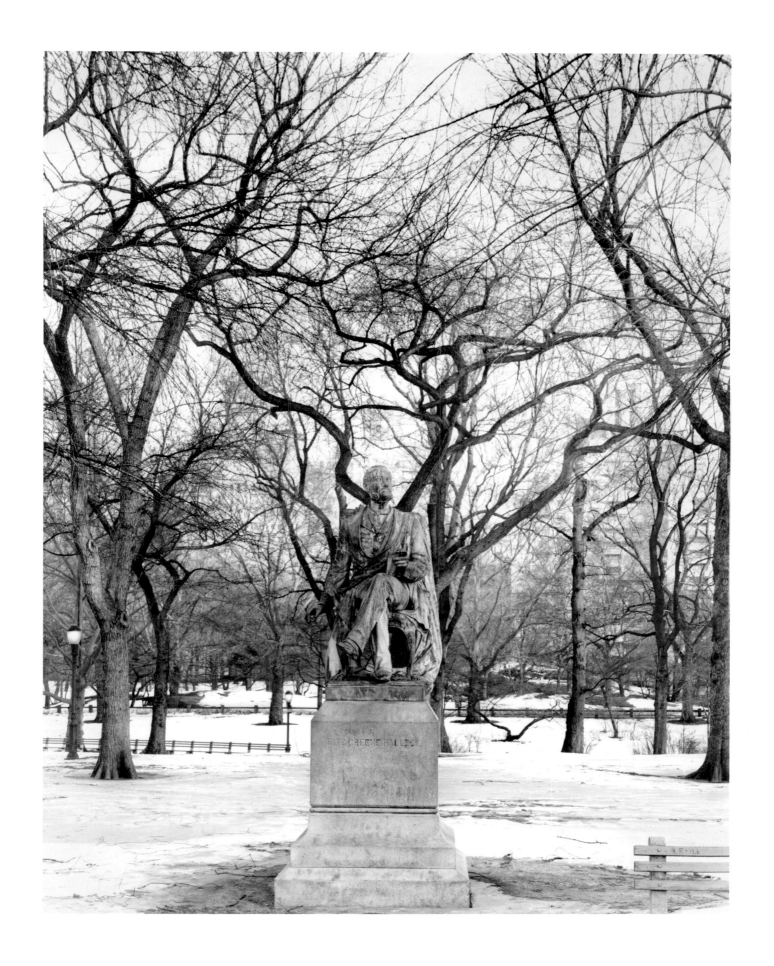

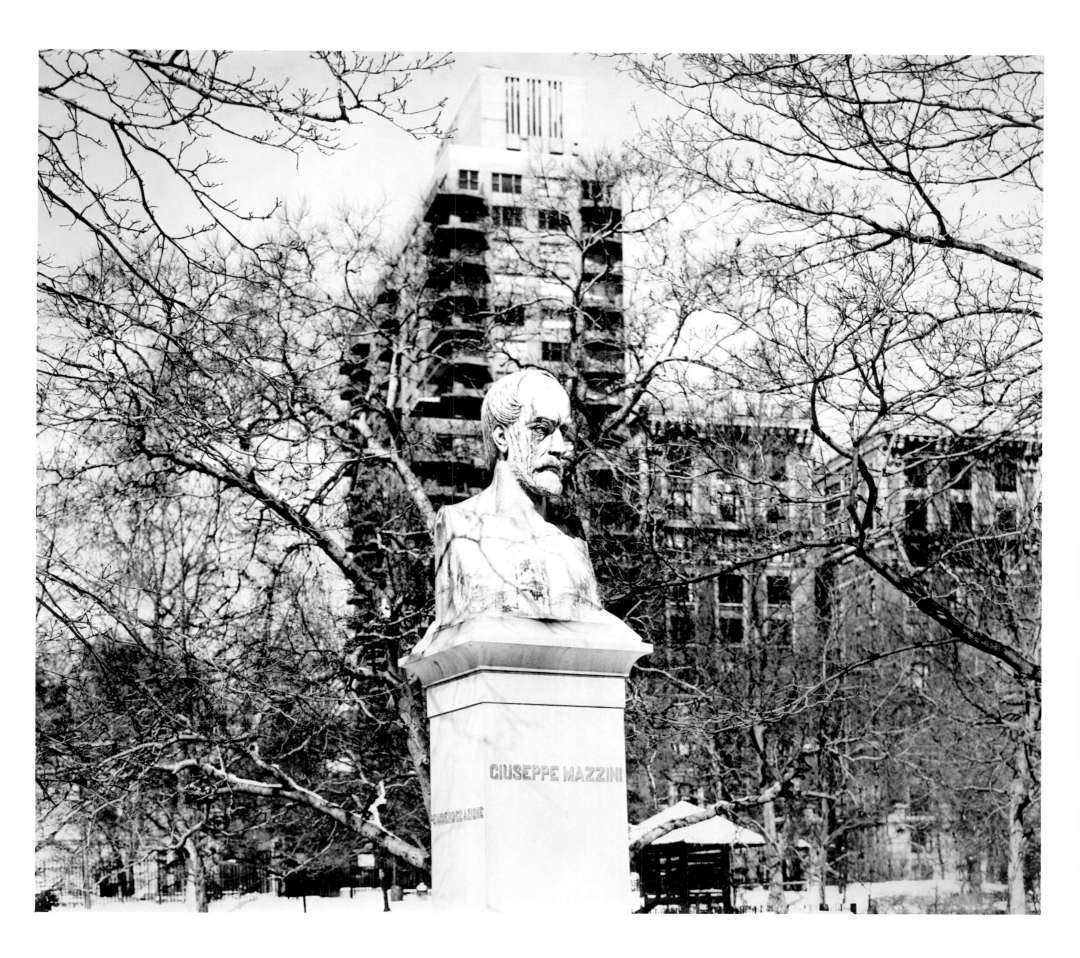

Locations

The views shown in these photographs were selected on aesthetic grounds; that many of the buildings shown may be architecturally significant is, in truth, accidental, for architectural importance was not the photographer's primary concern. The following identifications are provided merely to satisfy the curiosity of the interested reader.

11. Columbus Circle, intersection of Eighth Avenue and Broadway, looking toward the Maine Memorial and the New York Coliseum.

12. Cooper Union Foundation Building, Cooper Square and Astor Place.

13. Metropolitan Life Insurance Company, North Building, Madison Avenue and East Twenty-fifth Street, looking toward the Flatiron Building (Fuller Building).

15. 13-15 West 122nd Street.

16. Cooper Union Foundation Building.

17. Former United States Federal Archives Building, Washington to Greenwich streets, Barrow to Christopher streets.

18. E. V. Haughvout & Company Building, 488 Broadway (at Broome Street).

19. Northwest corner of Broadway and Twelfth Street.

21. Park Avenue, between East Sixth-ninth Street and East Seventieth Street.

22. Former Hugh O'Neil Dry Goods Store, Avenue of the Americas at Twentieth Street.

23. 429 Broadway.

25. The Spanish and Portuguese Synogogue, southwest corner of Central Park West and Seventieth Street.

26. Intersection of Wall, Nassau, and Broad streets, looking toward Federal Hall National Memorial.

27. Appellate Division, New York Supreme Court, Madison Avenue at Twenty-fifth Street.

28. Citicorp Center, Third Avenue between East Fifty-third Street and East Fifty-fourth Street.

29. New York Stock Exchange, Broad and Wall streets.

31. United States Government Customs House, Bowling Green, and United States Lines Building, One Broadway.

32. Riverside Drive at West 134th Street.

33. General Grant National Memorial, Riverside Drive at West 122nd Street.

35. Chrysler Building, 405 Lexington Avenue, from the fifty-eighth floor.

36. Beaver Street at William Street.

37. United States Government Customs House, Daniel Chester French Sculpture.

38. 115th Street, west of Lenox Avenue.

39. Beaver Street at William Street.

41. Irving Trust Company and the New York Stock Exchange, Wall Street.

42. Saint Patrick's Cathedral, Archbishop's (Cardinal's) Residence, and Lady Chapel, Madison Avenue between East Fiftieth Street and East Fifty-first Street.

43. Herald Square, intersection of Sixth Avenue and Broadway.

45. Madison Avenue Presbyterian Church, Madison Avenue and Seventy-third Street.

46. West 144th Street, between Amsterdam Avenue and Convent Avenue.

47. Lenox Avenue, between West 123rd Street and West 124th Street, Ephesus Seventh-Day Adventist Church (originally Reformed Low Dutch Church of Harlem).

48. 2006 Fifth Avenue between West 124th Street and West 125th Street.

49. Former Home for Respectable Indigent Females, Amsterdam Avenue between West 103rd Street and West 104th Street.

51. Metropolitan Life Insurance Company, North Building, Madison Avenue and East Twenty-fifth Street.

52. Bryant Park, Forty-second Street and Avenue of the Americas.

53. W. R. Grace Building, 41 West Forty-second Street.

55. Pulitzer Fountain, Grand Army Plaza, Fifth Avenue between East Fifty-eighth Street and East Fifty-ninth Street, looking toward the General Motors Building.

56. India House (formerly the New York Cotton Exchange), Hanover Square.

57. 418 Central Park West, between West 101st Street and West 102nd Street.

59. Solomon R. Guggenheim Museum, Fifth Avenue between East Eighty-eighth Street and East Eighty-ninth Street.

60. Cathedral Church of Saint John the Divine, Cathedral Heights, Amsterdam Avenue at West 112th Street.

61. Cathedral Church of Saint John the Divine.

62. Federal Post Office, Church Street and Vesey Street.

63. West Thirty-fourth Street, between Seventh Avenue and Eighth Avenue.

65. Times Square, at West Forty-third Street.

66. Pratt–New York Phoenix School of Design (originally New York School of Applied Design for Women), northeast corner of Lexington Avenue and Thirtieth Street.

67. Former Hotel New Yorker, Eighth Avenue and Thirty-fourth Street.

68. Broadway and West Thirtieth Street, looking toward the Empire State Building.

69. Former New York Life Insurance Company Building, 346 Broadway, looking toward 26 Federal Plaza and the United States Courthouse.

71. From the American International Building (originally Cities Service Company Building), 70 Pine Street.

72. From the Empire State Building, 350 Fifth Avenue.

73. From the Empire State Building.

74. Chrysler Building, 405 Lexington Avenue.

75. New York Stock Exchange, Broad Street.

77. From the Equitable Building, 120 Broadway.

78. Chrysler Building.

79. Chrysler Building.

81. Fifth Avenue at Twentieth Street.

82. Broadway at Pine Street, Equitable Building and the Bank of Tokyo (former American Surety Company Building).

83. Looking west from Coenties Slip and Pearl Street.

85. Wright Brothers School, Amsterdam Avenue and West 155th Street.

86. 345 Park Avenue South, between Twenty-fifth Street and Twenty-sixth Street, reflecting the Metropolitan Life Insurance Company, North Building.

87. Water Street, between Gouverneur Street and Wall Street.

88. Northeast corner of Broadway and Twenty-ninth Street.

89. From the Equitable Building, 120 Broadway.

91. From the American International Building, 70 Pine Street.

92. Church Street, between Cortlandt Street and Fulton Street.

93. Metropolitan Life Insurance Company Tower, One Madison Avenue.

94. Saint Patrick's Cathedral, Fifth Avenue, East Fiftieth Street to East Fifty-first Street.

95. Trinity Church, Broadway at Wall Street.

96. Facade of Squadron A Armory, Madison Avenue between East Ninety-fourth Street and East Ninety-fifth Street.